Silversmithing

A Contemporary Guide to Making

Silversmithing
A Contemporary Guide to Making

Brian Hill and Andrew Putland

THE CROWOOD PRESS

First published in 2014 by
The Crowood Press Ltd
Ramsbury, Marlborough
Wiltshire SN8 2HR

www.crowood.com

© Brian Hill and Andrew Putland 2014

All rights reserved. No part of this publication may be reproduced or transmitted in any form or by any means, electronic or mechanical, including photocopy, recording, or any information storage and retrieval system, without permission in writing from the publishers.

British Library Cataloguing-in-Publication Data
A catalogue record for this book is available from the British Library.

ISBN 978 1 84797 615 4

Acknowledgments
The authors have enjoyed the high spirit of liaison and collaboration from the industry in compiling this book. In particular we thank The Goldsmiths' Company and The Goldsmiths' Centre for their incredible and invaluable support. With special thanks to Eleni Bide, David Beasley, Alison Byne, Robert Organ, Rosemary Ransom Wallis, Gerry Tiling and Richard Valencia.

Live visits to workshops at The Goldsmiths' Centre have been crucial in capturing manufacturing techniques that feature throughout the book. Our appreciation and gratitude extends to John Need, Reg Elliot, Alan Fitzpatrick, Sam Marsden and James Neville for their expert help and assistance.

The computer illustrations bridge theory and practice, generated and crafted by Richard Gamester, and we thank him for his significant contribution.

In Chapters 4 to 6 the substantial image commentary has been generously supported by photographer Lee Robinson, we thank him for his contribution.

Our thanks also go to the Goldsmiths' Craft and Design Council for the use of some images.

Typeset by Servis Filmsetting Ltd, Stockport, Cheshire
Printed and bound in India by Replika Press Pvt Ltd

Cover images
Front cover: Brett Payne, X–Y candlesticks.
Back cover: Andrew Putland, hand raising a silver beaker; Grant Macdonald, RP pattern created from liquid resin.
Front inside flap: Padgham & Putland, soldering a scored and folded box.
Back inside flap: co-authors Brian Hill (left) and Andrew Putland.

Frontispiece
Silver chandeliers by Padgham and Putland, using a stainless steel skeleton. Commissioned by Prime Development Ltd and Nicola Bulgari.

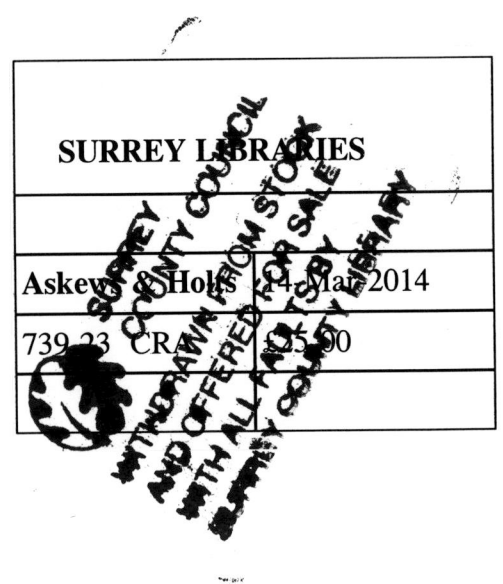

CONTENTS

Introduction		*6*

1	History, hallmarking and assay	9
2	Materials, tools and equipment	37
3	Health and safety	47
4	Manufacturing techniques, methods and processes	53
5	Polishing and finishing	111
6	Surface decoration and decorative treatments	121
7	Technology in a traditional craft	137
8	Designers in industry	165
9	Designer-makers	171
10	The next generation	187

Further Information	*198*
Glossary	*202*
Index	*206*

INTRODUCTION

The unique craft of silversmithing has managed to survive the passage of time; its traditional skills, techniques and processes are still relevant for practising silversmiths in the twenty-first century. For modern silversmiths, particularly the self-employed, this is an exciting and rewarding time to be engaged in this popular area of the precious metals specialist crafts. Designers continue to demonstrate creative expression and individuality through their three-dimensional work, whether focusing on conventional, skills-based techniques or harnessing new production and technological advances. The collective outcome guarantees that there is something appealing, distinctive and attractive for everyone's attention, appreciation and admiration.

The primary aim of this book is to inform, inspire, encourage and direct those who wish to learn more about the practical craft of silversmithing, whether they are students, enthusiasts or designers. Additionally, it can serve as a useful compendium for practising silversmiths. The book has a strong vocational and practical ethos, aimed at guiding readers through a hands-on, step-by-step approach that encourages interested parties to have a go and become experiential learners.

The book's central remit and intention is to relay the traditional making aspects of the craft in a contemporary context, alongside the more recent technological advances. These advances offer stimulating opportunities for designers and makers to develop, increase and enhance their portfolio of skills, experience and overall capabilities.

The number and palette of designer-makers engaged in silversmithing increases year on year and the abundance of outlets for self-employed practitioners continues to grow. A high percentage of these designer-makers have taken the college/university route of training, and the book is very much addressed to this vibrant population, who will benefit from its vocational stance, practical advice and emphasis on the value of education.

The historical section highlights some important and striking examples of hand-craft and production skills employed on pieces of silverware; these leave us in awe of the skills and abilities of former craftspeople.

It is possible to engage in meaningful silversmithing within humble surroundings using a basic set of tools and equipment. The early chapters detail this starting point before moving on to more involved workshops for business, relating to established companies and the self-employed. There are many ways to make costs bearable and sustainable when setting yourself up: for example, communal group workshops are popular and economically viable. As well as the financial benefits that sharing resources provides, the supportive culture and working ethos that come with it encourage and accelerate learning in this type of community.

Of course it needs to be remembered that even with an extensive range of tools, equipment and machinery at your disposal, without the fundamental origins of skill-based learning, everything becomes harder and takes longer to achieve. It is these core and essential skills that everything else revolves around and emanates from. There is no substitute for these inherent craft skills and the resulting confidence and experience will serve you well as you develop your own interests, style, direction and subsequent career pathway.

Manufacturing techniques and methods along with production processes take centre stage in this book, to help engender skills-based learning as a basis for promoting the traditional methods of making, which remain irreplaceable. They hold the key to successful, high-quality making of a professional standard, and serve as an excellent foundation from which all other things evolve, develop, progress and prosper.

INTRODUCTION

The many decorative treatments that are available to the silversmith extend a range of visual qualities to designs, offering greater levels of contrast and impact. Allied aspects of the craft, such as chasing, engraving and enamelling, are excellent examples that give form, detail, colour, refinement and enrichment. The chapter on surface decoration illustrates the significant contribution that these forms of decoration can provide on larger-scale work.

Over recent years computer aided design (CAD) has developed to a point where it is now difficult to separate the real from the virtual. This challenging and pioneering period has seen a substantial shift towards design, particularly the rendering of large-scale work, and this area of rapid progression in silversmithing is an important aspect for inclusion in the book.

For some time, rapid prototyping has been the logical extension from CAD and this is now widely used in the construction of domestic and ecclesiastical products, models and artefacts, and in some cases has revolutionized the way parts can be accurately produced. Additionally, the use of laser and TIG welding has offered positive assistance to the silversmith and this technological development needs to be recorded, utilized and celebrated widely as we seek to improve our capabilities and calibre of work.

The chapters on designers in industry and designer-makers profile an extensive and diverse range of technical processes and aesthetic styles. There is such depth and breadth of activity in silversmithing that the entire book could easily have been taken up by portraying some of the many gifted designers and their varied and beautiful work.

The concluding chapter describes a positive future from the next generation of silversmiths, and in particular highlights the vibrant, talented and diverse range of designer-makers who are embarking on their career. These are sole traders who design and manufacture a wide array of creative and appealing products, wares and *objets d'art*. None of these up-and-coming creative designers will say that 'doing your own thing' is easy or straightforward; however, they all share a common passion, belief and conviction that they are indeed fortunate to be able to design, produce and sell their own bespoke work. We believe that this creative and talented community will make a positive and significant contribution to the design movement in the twenty-first century.

Wine cooler by Scott and Smith.

CHAPTER ONE

HISTORY, HALLMARKING AND ASSAY

History – an introduction

The central objective of this section is to draw attention to some of the outstanding craftsmanship, creative and technical skills in work that has been crafted and manufactured in past generations.

There are countless fantastic pieces of silversmithing from history that can inspire, inform and educate us, and this great asset should be a constant source of inspiration and reference for any silversmith who aspires to be a designer and maker of note. To this end, and to help get a good perspective and understanding of our silversmithing roots, we have focused on a selection of historical pieces that are part of The Goldsmiths' Company silver collection.

The writing that accompanies the images below is structured in two ways: the opening description of the pieces takes a contemporary angle and includes important and interesting details, facts and information; the main body of text focuses on a craftsman's summary and analysis of the making, skills and craftsmanship involved in each of the specific pieces. This approach gives an unusual and welcome scrutiny, attention and focus to work that is in the excellent/outstanding category, and therefore helps us to reflect on the astonishing examples of craftsmanship that are available for us to research, admire, respect, record and measure.

The quality of work described in this chapter also needs to be placed in the context of the limited tools and equipment that were available, and the lifestyle and working conditions of craftsmen back in the early eighteenth century, although these would have improved and developed over time. They certainly didn't have anything like the vast array of tools, equipment and technology that we have around us today, and this only serves to heighten our respect and admiration for the work they produced, the technical and artistic challenges they mastered, and the incredible standards that were attained.

In our study of these pieces there are many examples of silver gilt finishes, synonymous of the periods covered. Apart from the obvious decorative enrichment, this process also protected silver surfaces from oxidation, hence reducing the frequency of cleaning. Silver gilt is a process of applying gold by electroplating.

Monteith bowl by Edmund Pearce, 1709

Monteith bowls were developed at the end of the seventeenth century as a way of chilling glasses, important when serving fashionable cooling drinks such as punch. They were filled with iced water and early examples had simple, notched rims which held glasses upside-down by the foot so that the bowl of each glass was submerged and the glasses, which were expensive to replace, didn't bump into each other.

George Ravenscroft invented lead glass at the end of the seventeenth century. Glasses were expensive and were washed during meals to be re-used because of their value. By the beginning of the eighteenth century the rims of these bowls had become highly decorative, like this example, which features ornate scrolls, dolphins and satyr masks. The fluting found on the body of this Monteith bowl is also typical. The technique would not only have been easier to carry out in the softer Britannia silver, the standard that was compulsory between 1697 and 1720, but would also have made the bowls stronger. According to a contemporary writer, the name 'Monteith' comes from 'a fantastical Scot called "Monsieur Monteigh" who wore a cloak with scalloped

HISTORY, HALLMARKING AND ASSAY

ABOVE: **Monteith bowl by Edmund Pearce, 1709.** Size: Height 28cm × Width 37cm (H 11" × 14.5"); Weight: 4,227gms (136 troy oz).

BELOW: **Monteith bowl (detail).**

edges'. His fame didn't last, but the bowls remained popular into the 1720s.

This Monteith bowl shows some fine skills, ultimate control and incredible detail through carefully crafted chasing work, transforming the hand-hammered generic bowl into a refined, more delicate and attractive piece of silverware. The hallmark of hand hammerwork is in plentiful supply on this piece and such control and execution allows you to easily see and appreciate this lovely work. Because of its design, the craftsman's work is also apparent on the inside of the bowl, therefore increasing the aesthetics and visual power of the piece.

The chasing sections on the rim of the bowl have been crafted separately and then applied; not only do these decorative additions beautifully complement and balance the design, they also contribute to the strength of the rim and support the drinking glasses that would be positioned around it. The strength of the rim was important in this instance because it is a detachable section and consequently more prone to damage and abuse. Without the decorative rim in place the vessel can be used as an ordinary bowl and therefore serve a number of different functions. The base detail has been chased and modelled, the pattern providing both strength and authority to the piece but also lightly reflecting up into the main body of the bowl, offering greater visual qualities of reflective illusion to the piece.

The handles were modelled, probably in wood, and sand cast in two sections. Light chasing, almost mimicking that of engraved cut lines, is also present above the main body flutes and allows the stronger detail to blend and fade into the bowl's body.

The Monteith bowl is a marvellous example of how applied decoration can contribute positively to the visual, aesthetic and structural qualities of large-scale silversmithing, with the added value of seeing this detail on both the inside and outside of the design. The modelling, light chasing/repoussé work and engraving give further refinement and these aspects collectively make this strong bowl more attractive, desirable and appealing.

Chocolate pot by Joseph Ward, 1719. Size: Height 30cm × Width 18cm (H 12" × 7"); Weight: 1,514gms (49 troy oz).

Chocolate pot by Joseph Ward, 1719

Drinking chocolate arrived in England in the mid-seventeenth century, around the same time as two other exotic hot drinks, tea and coffee. It was the most expensive of the three beverages, and the most complicated to make. Early recipes call for chocolate 'cakes' from the Americas to be ground up with other ingredients like milk, claret, vanilla and eggs. The vessels that were developed to hold this elegant drink often had a hinged finial on the lid which allowed a rod to be inserted to stir the mixture. By the early eighteenth century both chocolate and coffee pots were tall and tapering in form. This example follows what is sometimes known as the 'geometric style', popular in England between the 1680s and 1730s. The

octagonal section complements the function of the pot perfectly: the angles are not so sharp that they become susceptible to damage, and the number of sides means that the spout and handle can be placed opposite each other.

The clean lines and an uncluttered appearance of this domestic and very functional piece from the early eighteenth century disguise how demanding it is to construct such a design. This type of domestic silverware calls for a very different set of skills compared to hand raising and chasing, for example. The main body would have started life as a seamed and tapered cone before the very difficult task of hammering it into its octagonal section was begun, and this task alone requires a great deal of skill, experience and capability in a craftsman. Quite apart from the accuracy needed to shape this into eight equal sides, the degree of difficulty in manufacturing this design remains ever-present at each and every stage of construction.

Processes and techniques deployed would have included: stake and template making, accurate marking, mitre work, forming and box making, fitting wires and handles, hinges and soldered assemblies. The spout has been modelled and cast in two sections and the hinge of the main lid boasts a safety chain attached to the rivet pin, even though the lid can open fully for washing and cleaning. The secondary lid is also hinged to enable access and storage of the stirring stick.

This design relies heavily on high-quality making; craftsmanship is paramount. Allied to this are the aesthetic qualities that this striking and exacting piece of silverware exudes if made as it should be. The design is a masterpiece of its period and style; it also looks – and probably still is – a very functional and successful domestic product from the eighteenth century.

Water fountain by Peter Archambo, c. 1728 (later hallmarked 1929)

Made by the silversmith Peter Archambo for George Booth, 2nd Earl of Warrington, this substantial piece of silver would have played an important part in aristocratic dining. It was intended for the sideboard at the Earl's country seat of Dunham Massey, and sat alongside a variety of other silver, to be viewed and admired as the height of the fashionable baroque style by his dining companions. Fountains like this one contained water to rinse glasses – the wine itself was kept chilled in a massive silver cistern which stood nearby. The

Water fountain by Peter Archambo, c. 1728 (later hallmarked 1929). Size: Height 71cm × Width 47cm × Base 30cm (H 28" × 18.5" × 12"); Weight: 17,884gms (575 troy oz).

design of the fountain reflects the early-eighteenth-century emphasis on imposing forms, with the decoration playing a supporting role. The handles are mounted on two rampant boars, the Warrington supporters from the Earl's coat of arms, whilst the cover features an Earl's coronet.

It weighs an impressive 575oz, which helps to explain why it originally had fraudulent hallmarks: Archambo, to avoid paying the high tax of sixpence per ounce which was imposed on silver at that time, submitted a small waiter (a tray, salver or plate) to the Assay Office for marking. This was let in afterwards as the base of the fountain. In order to be sold at auction in 1929 it was sent in to the London Assay Office to be fully tested and hallmarked according to that date.

The substantial structure, form and size of this fountain positively contributes to its majestic statement of strength, power and authority. This significant piece depicts two main skills: the demands of the silversmith through excellent control

HISTORY, HALLMARKING AND ASSAY

Water fountain (detail).

and forming by hammering on all the component parts of this striking vessel; and the substantial array of chasing and artistic detail that adorn and beautifully decorate this iconic eighteenth-century design. The majority of the ornate detail is modelled, chased and then applied to the fountain. Three-dimensional modelling skills have also been most effectively deployed on the cast hollow animal handles and functional tap/s.

The hammering, forming and shaping of this vessel would require a highly experienced silversmith to produce such bold, definite and exacting shapes; and much time, application and experience were needed to manufacture this type of work to such a high standard of execution. On studying the magnificent chasing and modelling, it could be argued that the skill and artistry invested by a modeller/chaser on this fountain would equal that of the smith who created the main form and structure. Wherever you look, it is worth scrutinizing the chasing and modelling work: it is simply exquisite and breathtakingly beautiful. The feel, control and execution of detail, the precision in relief work, and the artistic portrayal are top class. The modelling of the wild boar for the handles matches the overall standard, and the higher-profile chasing on the figureheads is another fine example of the work of craftsmen at the top of their trade. The whole piece therefore sets a great benchmark for us to aspire to, and exemplifies an early-eighteenth-century workshop employing skilled craftsmen in a number of disciplines under the direction of leading Huguenot silversmith, Peter (Pierre) Archambo.

Sideboard dish by Paul de Lamerie, 1740/41

Most large pieces of silver are made to impress, but this dish, elaborate, huge in size and richly gilded was created as a celebration of the prestige and wealth of one of goldsmithing's most important institutions. It was made in the workshop of Paul de Lamerie, the most famous silversmith of the eighteenth century, and is regarded as an important example of rococo design.

The son of refugees who fled religious persecution in France, de Lamerie showed early talent as a craftsman and businessman, and rose to become a senior member of The Goldsmiths' Company (despite a sometimes alarming disregard for its rules). In 1740 The Goldsmiths' Company commissioned him to make new items of plate commemorating gifts of silver which had been sold for cash during the hard times of the previous century. With a 6-inch border featuring exuberant rococo decoration and a large coat of arms at the centre, the dish embodies the Company's confidence and return to fortune. Senior members thought it was 'performed in a very curious and beautiful manner', and didn't even mention that it cost considerably more than de Lamerie's initial quotation.

This masterpiece demonstrates the ultimate skills and artistry of the silversmith where the main techniques of sinking, modelling and chasing have been beautifully exercised and interpreted on this large-scale iconic piece. Cut card, modelling, surface decoration, pre-chased and applied sections, all contribute to a stunning effect and visual statement. Apart from the skill demands, the sheer size of this dish (nearly a metre in diameter) and the volume of the work involved meant that this substantial dish would have tested the very best of craftsmen for endurance, concentration and sustained application throughout its manufacture.

The majority of the chasing on the outer circle surrounding the centre dish has been chased on the actual dish itself with some higher-profile sections chased and modelled independently and brought on. Other areas would have been modelled, cast and lightly chased and subsequently applied to the dish. The height, depth and dimensional nature of chasing on the central feature, the Goldsmiths' Company coat of arms, is quite breathtaking and the images selected capture this

HISTORY, HALLMARKING AND ASSAY

Sideboard dish by Paul de Lamerie, 1740/41. Size: Diameter 85cm × (D 33.5"); Weight: 11,960gms (384 troy oz).

Silver gilt ewer and dish by Paul de Lamerie.

amazing work for all to marvel at and to admire the artistry, the bold and expressive form, and the overall craftsmanship.

The degree of technical difficulty, the scale of the work and the quality of craftsmanship achieved on this and similar pieces of de Lamerie, leave no doubt that he was a master silversmith from the eighteenth century.

Ewer by Paul de Lamerie, 1740/41

Before the spread of the table fork, ewers and dishes or basins had a practical purpose in formal dining. Scented water was poured from the ewer over the hands and collected in a dish below, allowing guests to wash their hands at the table. By the time this example was commissioned, however, it was no longer considered polite to eat with one's fingers, and such objects were used to decorate buffets and sideboards, becoming larger and more elaborate in the process.

The upturned helmet-shape of this ewer is European in origin; it shows how new, fashionable designs were brought to London by refugee goldsmiths like de Lamerie. Its decoration follows a marine theme, appropriate for a water vessel. On the lower part of the body a winged mermaid swims alongside small tritons (sea messengers) blowing conch shells, while the handle takes the form of a gigantic marine god.

HISTORY, HALLMARKING AND ASSAY

Silver gilt ewer by Paul de Lamerie.

Ewer by Paul de Lamerie (detail). Size: Height 49cm × Width 42cm (H 19" × 16.5"); Weight: 5,849gms (188 troy oz).

In its highly detailed and extensive craftsmanship, which comprehensively covers this dynamic ewer from top to bottom, this is yet another great piece from the de Lamerie stable. The bold, assertive, rich and lavish use of decoration is a fine example of rococo design; the smithing, modelling and chasing applied to this piece takes on a majestic and somewhat Herculean dimension through its strength, power and aura.

The ewer itself is very heavy and immediately indicates that practicality and function were not a high priority when it was designed and made. This showpiece is not easy to lift, handle and use, but what immediately strikes you is its visual power, authority and command. The main body was probably made in two sections and a high percentage of the modelling and chasing were crafted independently and then brought onto the vessel. The substantial handle, which tends to dominate your attention as a main feature, would have been modelled and cast in sections, and the weight and positioning of this alone has obvious balance and stability issues. However, this has been resolved by incorporating some counter-balancing from a clever three-pointed base unit that has also been sand cast, with applied modelled/chased sections added at a later stage. The base design, size and proportions have been carefully considered: the weight from this well-proportioned base enables the vessel to defy the laws of gravity, as it should tip over when being displayed, positioned or put to use as a functional vessel.

Collectively, the detail, enrichment and ornate decoration is stunning in this fine example from its period, demonstrating excellent craftsmanship and showing how powerful and dynamic silverware had become in the eighteenth century. Even if you don't personally like the work and distinctive style from this very expressive period, it is difficult not to acknowledge, respect and admire the substantial contribution, creative and technical achievement that this type of design and craftsmanship generated; they are significant and powerful statements.

Sweetmeat basket by William Plummer, 1759

The maker of this basket, William Plummer, seems to have specialized in producing pierced, saw-cut objects. A fairly high number have survived, suggesting he had a large and productive workshop, skilled in these particular techniques.

HISTORY, HALLMARKING AND ASSAY

Sweetmeat basket by William Plummer, 1759. Size: Height 12cm × Width 14cm (H 5" × 5.5"); Weight: 196gms (6 troy oz).

Sweetmeat basket (detail).

The elaborate design of the basket shows the influence of the rococo style, which placed an emphasis on fantasy and detail. It was probably used to contain sweetmeats, the name given to food served in the final, sweet course of a meal. Sweetmeats were often the most visually impressive (and expensive) part of a meal, which meant the vessels used to serve them could be correspondingly flamboyant. This basket was once part of an *epergne*, an elaborate centrepiece with multiple branches holding small containers for different delicacies.

This small, delicate and beautifully proportioned sweetmeat basket would grace any setting or occasion and perfectly illustrates how extensive pierced decoration can make a vessel look attractive – so open and lightweight – yet retain sufficient strength from its original formed structure. To achieve this balance a craftsman needs to acquire a good understanding of the structure and strength of the main shape before removing a high percentage of the surface area through piercing to achieve this type of detail, pattern and the open effect.

Quite apart from the core smithing techniques of hammering and additional ribbed chasing to create the form and main body of this basket, the applied and pierced detail transforms the piece into an open-structured and lightweight vessel, establishing its own identity and lavish style. The applied sections make a significant contribution to the appearance and strength of the basket where forming, piercing and modelling have all contributed to the base, lip and handle sections of the vessel. These parts would have been taken through to reproduce in quantity by creating master patterns for casting; the reproductions were then applied by soldering or riveting. William Plummer's basket, as in other silversmithing examples that we have used in this chapter, is a good demonstration of the considerable effect and striking impact of these decorative techniques, giving vitality and eye-catching appeal to a piece of silverware. Adding sweetmeats to this adorable piece further enhances its visual impact and attractiveness; it is difficult to imagine how anyone would not warm to this lovely style and popular decorative piece of petite silverware.

Teapot by Michael Plummer, 1787

Whilst coffee was preferred in Europe and America by the close of the eighteenth century, the British were drinking on average more than a pound of tea each per year. Manufacturers responded to this popularity by producing a profusion of tea paraphernalia, the most important piece of equipment being the teapot. The tapering facets of this

Teapot by Michael Plummer, 1787. Size: Height 16cm × Width 26cm (H 6.5" × 10"); Weight: 513gms (16 troy oz).

HISTORY, HALLMARKING AND ASSAY

Teapot (detail), showing the applied engraving and light carving on the panels of the main body.

example are unusual, but not unique. In contrast to the more common cylindrical teapots of the late eighteenth century, its form is inspired by ancient vases, reflecting the prevailing neo-classical style. The wooden handle and ivory finial would have made the teapot easier to handle and use when filled with hot liquid.

Whichever way one analyzes the manufacturing techniques deployed on this elegant piece of silversmithing, it shows an impressive combination of production techniques deployed at the time of the Industrial Revolution, supported by hand-craft skills, to form, fit and assemble this sophisticated and complex construction.

The confidence and experience needed to manipulate forms by stamping, forming and hammering would have been a fair test for the craftsmen and engineering ingenuity of the time. But clearly these skills were refined, developed, mastered and delivered in this oval-sectioned teapot.

The deeply ribbed detail on the main body extended the requirement of processes and techniques to take silver into such deep sections and in multiple positions. This would have tested the metal's malleability and craftsmen's skill in taking sheet metal across three different form directions. Here was a real examination of what could be achieved in form, line and direction in search of stylish yet functional products.

The main body would have been made up in two separate sections because otherwise the metal would not have been able to tolerate such extremes of depth and force, but this method and approach then generates incredibly difficult fitting requirements when bringing these sections together in assembly and preparation for soldering.

To varying degrees the spout, handle sockets and base of the teapot are all technically demanding and collectively this piece shows a wide range of processes, techniques of production and hand skills, including stamping, forming, hammering, fitting, assembly and soldering of component parts.

Applied engraving and light carving on the panels of the main body, circumference and centre section of the lid give added value to the refinement and sophisticated ethos of the design. It is possible that some of this fine detail could also have been achieved by light chasing but there is insufficient evidence on this example. Quite apart from the range of its technical attributes, the design appears to answer all the practical requirements of stability, pouring, handling and insulation; in short a fine example where all the important criteria seem to have been answered extremely well.

The flush hinge on the teapot lid is beautifully hand crafted and integrates so well on the piece it is hardly noticed as the decorative engraving flows around this area. The base of the teapot is also a good example of production, hand-fitting and assembly techniques. The ribbed detail around its circumference perfectly complements the intense detail on the main body and the remaining generic form of the base provides a welcome and effective contrast on the vessel as it mirrors the same aesthetic on the lid of the teapot.

Wine cooler (one of four) by Scott and Smith, 1806

Despite on-going hostilities with Napoleon, elements of this wine cooler show that French design was still influential in Regency Britain. The contrast between the fluting at the base of the cooler and the polished surface of the body can also be found on the silver of the Parisian goldsmith Henri Auguste. The frieze of grapevines to the top of the vessel shows an entirely different influence, however: etchings of ancient Roman ruins by the Italian artist Piranesi. Like many examples,

HISTORY, HALLMARKING AND ASSAY

Wine cooler (one of four) by Scott and Smith, 1806.
Size: Height 22cm × Width 28cm (H 8.5" × 11");
Weight: 3,308gms (117 troy oz).

its collar and liner are detachable to make filling and cleaning easier. The coolers were made for the firm Rundell, Bridge & Rundell in their first workshop, overseen by Digby Scott and Benjamin Smith. Smith had previously worked for the industrialist Matthew Boulton, and appears to have managed the business side of the operation, whilst Smith was a draughtsman. His role was to translate designs supplied by artists into functioning pieces of silver.

This wine cooler displays a distinct and unified balance of visual aesthetics and a successful partnership between decoration and a calm, simplistic command of surface area, shape and proportion. This relationship enables both aspects to be viewed and admired independently whilst also working well together in harmony.

The chasing work gives us another fine example of great control, precision and execution in the fluting and flowing pattern of grapevines on the main body. The unusual and most effective fluting at the foot of the base has a somewhat contemporary feel and perfectly complements the dental-type pattern at the collar at the top of the cooler; this also fits with the overall design. Both of these sections, as well as the vertical collar at the base of the vessel, have been modelled and cast, and all play an important part in the unity of this design.

The chasing on the frieze of grapevines requires a more artistic and interpretive approach: this pattern, the piece's most effective feature, is allowed to flow and dance around its circumference. All of the chasing has been carried out on the actual piece; only the figureheads have been fabricated separately and then brought onto the main body. As on the Paul Storr wine cooler described in this chapter, the modelling and smithing work on the handles allow them to blend and become a natural part of the overall design. This is another fine case in point where function is not compromised by aesthetic considerations.

The skills of the engraver are beautifully demonstrated on the vessel; this example clearly shows what a significant contribution high-quality engraving with its artistic merits, including a real depth of expression, can make.

Wine cooler (one of a pair) by Paul Storr, 1810

The bell-like shape of this wine cooler is based on ancient Greek vessels known as *kraters*, which were used to store wine and water. Contemporary archaeological discoveries meant that during the Regency period, designs influenced by the ancient world were highly fashionable. In silver this also meant an emphasis on 'massiveness', which, as one commentator put it, was 'the principal characteristic of good plate' (C.H. Tathem). These wine coolers certainly have this 'heavy' quality, and also feature other classical motifs, including acanthus leaves and Bacchanalian scenes. They were designed by William Theed, a sculptor who ran the design and modelling studio of the retail firm Rundell, Bridge & Rundell. The designs were made up in the workshop of the silversmith Paul Storr. Other very similar wine coolers made by Storr for Rundell's still exist, suggesting that this was a popular style and much in demand in its time.

This fine example of an early nineteenth-century wine cooler shows high-calibre skills in silversmithing, chasing and modelling, for this type of work clearly demands great

HISTORY, HALLMARKING AND ASSAY

**Wine cooler (one of a pair) by Paul Storr, 1810.
Size: Height 27cm × Width 25cm (H 10.5" × 10");
Weight: 4,098gms (132 troy oz).**

Wine cooler (detail) by Paul Storr.

technical capability alongside artistic talent. These skills have been sensitively deployed, refined and mastered across a large percentage of the vessel's surface area.

The chasing shows a range of impressive techniques: excellent depiction and representation of human and animal form; flowing lines and delicate interpretation of natural shapes and forms; and highly disciplined execution and control with patterns. The small amount of applied wire and chased leaf work at the top of the vessel simply adds to this stunning use of allied aspects of the craft alongside the mainstream skills of the silversmith. The chasing at the top of the vessel (showing patterns and detail on the inner and outer edges of the main body) was crafted on site and is another fine example of chasing expertise and disciplined execution.

The modelled handles show sympathetic and complementary lines and divisions that enable them to integrate successfully, whilst retaining strength and function, and therefore do not dominate or overpower the design. On investigating the methods of construction on the main body of the cooler, the upper segment has been crafted in two separate sections and soldered together.

The lower, more bulbous shape is comprised of eight separate sections, and we believe these have been cast from master patterns, then further chased after the sections were soldered together to form a complete bowl shape.

It is possible that all the component parts of the bowl shapes were handmade as one-off pieces but as previously described, quite a number of these coolers were manufactured in this period, so aspects of reproduction may have been deployed. However, in judging this significant and impressive work, one can only marvel at the mastery of the craftsmen in the early nineteenth century and the methods they used in producing such creative and demanding work.

HISTORY, HALLMARKING AND ASSAY

Seven-light candelabrum (one of a pair) by Paul Storr, 1814.
Size: Height 95cm × Width 49cm (H 37.5" × 19");
Weight: 16,280gms (523 troy oz).

Candelabrum (detail).

Seven-light candelabrum (one of a pair) by Paul Storr, 1814

This candelabrum bears the hallmark of Paul Storr, but its history reveals a complex chain of retailers, designers and manufacturers, all of whom played a part in its creation. Between 1807 and 1819 Storr worked for Rundell, Bridge & Rundell, the most successful retail goldsmiths of their day.

In order to fulfil demand and keep control of the making process, the firm had established their own design studio and contracted workshops. At its peak, it employed up to five hundred people, and was said to use over 10,000 ounces (approximately 300kg) of silver a month. Already an established silversmith, Storr supervised production of high-quality silver, attracting royal and noble customers to Rundell, Bridge & Rundell. The different elements of this Bacchanalian candelabrum would have required and demanded the skills of a number of specialized craftsmen.

This very tall and majestic piece of work shows a rich array of specialist techniques and processes, where the manipulation of materials and impressive control through various stages of manufacture has resulted in a style and presence that demands attention, appreciation and respect from admiring fellow craftsmen, lovers of art and design and the viewing public in general.

Each of the many components of this amazing piece contains some specialist aspects to marvel at and greatly admire. The chasing shows extreme control, precision and regularity. Fluting on the main body and twisted wires shows sensitive, expressive and creative use of the materials and processes, and the modelling of figures, animals and the feet is exquisitely achieved and deployed throughout. Casting has been used to reproduce component parts on this and other candelabrum designs of this type. Furthermore, the applied wires, beads and other items support the whole, adding realism and

HISTORY, HALLMARKING AND ASSAY

contrast. Engraving and decorative carving work in harmony, further increasing the overall effect. This highly detailed and magnificent design deserves our appreciation and respect for its style, elegance and status, but especially because of the masterful craftsmanship that is evident wherever you choose to scrutinize it. This is a piece of dynamic silversmithing that would have turned heads, and received much praise and respect.

National Rifle Association rosewater dish, 1850

The National Rifle Association rosewater dish was designed by Benjamin Schlick and made by Elkington & Co. Ltd in 1850 in the Classical revival style. It depicts Amphitrite with Poseidon riding the waves. Established by the cousins George and Henry Elkington, this Birmingham firm is best known for patenting the process of electroplating in 1840. However, their factory, filled with the latest machinery (some powered by steam), also made solid silver objects. This commitment to technological innovation was soon matched by a concern for artistry, and by the time of the Great Exhibition in 1851 the firm was established as one of Britain's leading manufacturing silversmiths. To improve the quality of their designs, the firm worked with a variety of artists, including Benjamin Schlick. An amateur archaeologist from Denmark, Schlick supplied Elkington's with models of antique artworks from private European collections, and his own designs based on antiquarian themes. This dish, with its Renaissance flavour, reflects the wider interest in historic styles during this period. The firm's

National Rifle Association rosewater dish, 1850, designed by Benjamin Schlick and made by Elkington & Co. Ltd. Size: Diameter 65cm (D 25.5"); Weight: 10,528gms (338 troy oz).

HISTORY, HALLMARKING AND ASSAY

Rosewater dish (detail).

collaboration with the eccentric Schlick ended in 1851, the latter writing that a lack of sympathy for his sacrifice and hard work had 'cooled [his] love for England and the English'.

The central aspect of this rosewater dish is a feat of top-class modelling and chasing work, and here there is much to admire, marvel at and take inspiration from. The interpretation, representation and depth of expression in the central scene is like that of a talented artist setting pencil and paint onto paper or canvas, and the modeller and chaser have managed to re-create this brilliant art on metal – a great testament to craftsmen who are clearly at the top of their profession. By studying the severe depth, strength and contrast on this scene, and seeing the piece from the back, we believe that it has been modelled and prepared to be subsequently cast, where further chasing would have been required to sharpen and clarify the detail, contrast and definition.

The piece continues to impress as you study the regimented and symmetrical detail surrounding the centre scene, where control, accuracy and regular treatment with great attention to detail has to be maintained throughout 360 degrees to achieve such a command and powerful control. This positioned pattern seems a perfect way to contrast and enhance the free-flowing artistry in the centre of the dish.

The large surrounding rim of modelled, carved, pierced and applied detail supports the central feature without overpowering it. This modelling would have been produced in sections for casting, and following cleaning, chasing and refinement, they would have been soldered together and the complete unit would have been secured with bolts to the dish.

Again, the same can be said of the modelled or carved and lightly chased motifs carefully placed at north and south positions on the dish. The fine attention to detail continues on the outer rim of the dish through carved, engraved or partly chased motifs, allowing the soft decoration to give further enrichment and unity.

To summarize, this magnificent dish is comprehensively covered with top quality decorative aspects allied to the silversmith and to be able to demonstrate this in such a convincing and holistic manner makes it a fine example of decoration applied to a relatively light form of silverware; it is vibrant and dramatically transforms the article to a work of decorative art.

Fruit bowl by H.G. Murphy, 1938

Harry Murphy was a significant figure in inter-war British silver. He trained as an apprentice with Henry Wilson, and absorbed many of the Arts and Crafts values of traditional craftsmanship. However, he was dismissive of the movement's tendency to remove itself from industry, and went on to run a large, commercial workshop named the Falcon

Fruit bowl by H.G. Murphy, 1938. Size: Height 11cm × Width 44cm (H 4.5" × 17.5"); Weight: 1,067gms (34 troy oz).

Fruit bowl (detail).

The base unit simply and cleanly echoes the distinctive detail on the main body, where thick-gauge wire has been sculpted by filing to reflect, match and complement the fluting. Rims of delicate gadrooned wires succinctly and successfully divide and separate the bowl from its base, and this subtle approach is capped with the same treatment at the top of the bowl around the underside of its perimeter. This light and most delicate application beautifully complements the striking nature of the design, enabling both aspects to contribute to its stunning appearance. This is an excellent and harmonious example of fine craftsmanship (hand-hammering skills) alongside experience and confidence throughout its crafting. It is a piece of its time, and with the addition of fruit to adorn and decorate, this design would grace any setting, with its marvellous aesthetics, presence and status.

Studio. Murphy committed himself to improving training and technical education, teaching at the Royal College of Art and becoming Principal of the Central School. This bowl was hand raised with the help of Sidney Hammond, who taught with Murphy. Its design shows his keen interest in the innovative, modern styles emerging from continental Europe. He admired design which 'insists on results obtained by vigorous attention to functional requirements, and the simple, straightforward use of materials' – ideas that are perfectly embodied in this bowl.

What appears as a neat, simple and clean piece of silversmithing from the twentieth century masks how difficult and challenging this type of design and construction is to carry out and successfully manufacture to high standards. In fact, because of the design's ultra-simplicity, it is very easy to see if the work is sub-standard; there is nowhere to hide when craftsmanship and skill are being assessed. The slender and oval-sectioned hand-raised fruit bowl, with its notable and impressive concave fluting, takes the piece into advanced levels of silversmithing techniques and skills. This is a real test of hammering: no machine process or aspect of technology can help in this instance, but this only heightens the achievement of some first-class hammering, as seen in this impressive bowl.

Silversmithing through the centuries

The earliest accounts of working with precious metal reveal that many of the techniques used by ancient silversmiths would be familiar to today's craftsmen. Tablets from the city of Nineveh dating to the seventh century BC contain descriptions of different solders and alloys, while nearly two thousand years later Theophilus, thought to be a technician writing around AD1100, described shaping silver by raising, the use of stamps and dies, and the process of lost wax casting. The metal workshop he depicts, with its high, spacious rooms stocked with hammers, anvils, punches and other tools, seems in many respects highly desirable to the modern reader. Of course, not all of Theophilus' techniques are still useful: today it would be very unusual for a silversmith to have to refine their own metals, and few would want to try his recommended method of hardening engraving tools using the urine of a small red-headed boy.

It is impossible to know whether Theophilus expected silversmiths to master all the processes he described, but records show that they specialized much earlier than we usually imagine, giving them yet more in common with contemporary craftsmen. By the seventeenth century bullion was bought from specialist refiners, and important centres like London contained complex networks of expertise including engravers, chasers, and even designers. These individuals are often hidden from view as outworkers or as part of a larger business: Paul de Lamerie certainly masterminded the stunning dish and ewer shown in this chapter, but his hallmark

represents the efforts of a highly skilled team of competent craftsmen.

However, for all the continuity that can be traced over the centuries, the silversmiths' workshop was also often the home of the newest technical innovations. The Industrial Revolution, which began in the eighteenth century, saw the introduction of large rolling or flatting mills, producing sheet metal which saved smiths from having to beat out bullion. By the early nineteenth century large workshops like that of the Bateman family might buy their own steam engine, which could also drive large stamping machines, now capable of producing fine detail thanks to hard crucible steel dies. Writing in 1872, John Yeates commented, 'Machinery now lightens the labour of the gold beater, the wire drawer, the embosser and engraver, and performs processes once so toilsome with a rapidity and perfection which hand-work could never have approached.' Technology didn't necessarily make working life easier – large silversmithing factories made possible by mechanization could be cramped and poorly ventilated, and new methods like electroplating gave off toxic fumes – but new inventions continued unabated.

Silversmithing has always been a balance of tradition and innovation. If Theophilus visited a workshop today, he would be confronted with technology which to the medieval mind might look like magic and alchemy, but he could also recognize and work with tools that have remained essentially unchanged for thousands of years.

Hallmarking and assay

Silversmiths, goldsmiths and jewellers predominately manufacture their designs in alloyed silver, gold, platinum or palladium. However, there are some instances where work is fabricated in any of the pure precious metals. Designers like Hiroshi Suzuki, Vladimir Bohn and Martyn Pugh, for example, have crafted some of their work in pure silver or gold, and the technical term and reference used in this instance is 'fine' silver, gold, platinum or palladium.

Precious metals in their pure form are too soft to use for most requirements, so other metallic elements are added to create alloys which improve their mechanical properties, increase the inherent strength and durability, attain a desirable colour, and improve their working properties for producing items of silverware, smallwork and jewellery. Usually it is impossible to judge or ascertain the proportions and percentages of pure metal contained in the alloyed precious metal by visual appearance, weight or touch alone. This is one reason why it is a legal requirement to hallmark all designs that consist of silver, gold, platinum or palladium if they are being sold as precious metal items and products.

The hallmark, as well as providing a failsafe guarantee for manufacturers, importers, retailers, and of course the consumer, makes an attractive feature, providing a lovely presence and authority on silverware. When carefully positioned on a design, hallmarks give added value to the overall

Heather O'Connor's hallmark.

HISTORY, HALLMARKING AND ASSAY

London Assay Office marking.

aesthetics of silversmithing work, and many contemporary designer silversmiths use these to good effect on their work, including them as an integral part of their design.

Traditional marking

Hallmarks are traditionally applied by hand, and are struck into the metal with a steel punch, giving a beautiful deep and sunken imprint. These marks have proved to survive normal domestic wear and tear: as a testament to this, pieces that were examined and hallmarked centuries ago can still be identified today and this greatly assists in keeping accurate records of manufactured silverware since hallmarking began in the fourteenth century.

Miriam Hanid's hand-struck hallmarks.

The examples shown here perfectly illustrate how attractive traditionally struck hallmarks can be, and we believe that they will continue to appeal to all involved, but particularly to craftsmen and consumers. Although laser marking offers an excellent alternative, we believe there will always be a special place and continued demand for attractive hallmarks that are struck by hand; they are beautiful, bold, and give longevity of value.

LEFT AND ABOVE: Richard Fox's hand-struck hallmarks.

HISTORY, HALLMARKING AND ASSAY

Laser marking in progress.

Technology and contemporary applications

In recent years technology has made a substantial contribution to assaying and hallmarking, and all marks can now be applied using lasers. This clean and crisp method of cutting detail into the metal means that no raised bump is created, as occurs with the traditional technique of marking, but the laser mark doesn't have the same depth as the hand-struck ones, and therefore may not last as long (this could depend on where the marks are positioned and cut on a design).

Laser marks on 18ct gold by Marianne Forrest.

Laser marking on silver for silverware and jewellery by Heather O'Connor.

HISTORY, HALLMARKING AND ASSAY

Origins, history and value

The term 'hallmarking' dates back to 1478 when gold and silversmiths had to send their wares to Goldsmiths' Hall in London to be tested and marked. However, the concept of marking precious metals to show their purity predates this by well over a century. This rich history has made hallmarking not only one of the oldest and most successful forms of consumer protection but has also been an invaluable tool in the detection of fakes and forgeries, therefore enhancing the value of a wide range of silverware, jewellery, and other products. In addition, the contemporary silversmith can use a variety of laser markings, such as logos, monograms, signatures, and personal messages, which can positively enhance their marketing and branding.

ABOVE AND BELOW: **Assay testing by Cupel at The Goldsmiths' Company Assay Office, London.**

Hallmarking in the UK

Hallmarking in this country is governed and controlled by the UK 1973 Hallmarking Act and its subsequent amendments. Its main focus is based around description, where it states that it is an offence for any person in the course of trade or business to:

- Describe un-hallmarked articles as being wholly or partly made of gold, silver, platinum or palladium.
- Supply or offer to supply un-hallmarked articles to which such a description is applied.

Articles below a certain weight are exempt from hallmarking (although this is unlikely to be relevant to the silversmith due to the size and weight of large-scale work). The exemption weight is based on the precious metal content only, excluding for example, stones, except in the case of articles consisting of precious and base metals, in which case the exemption weight is based on the total metal weight. The exemption weights are as follows:

Platinum: 0.5g
Gold: 1.0g
Palladium: 1.0g
Silver: 7.78g

THE UK HALLMARK

The UK hallmark comprises of three compulsory symbols or marks:

1. The sponsor's or maker's mark: this indicates the maker or sponsor of the article. It consists of a minimum of two initials within a shield. For obvious reasons, and like a thumbprint, no two makers' marks can be the same.

Maker's mark: Padgham & Putland.

London Assay Office mark.

HISTORY, HALLMARKING AND ASSAY

Maker's mark: Richard Fox.

Maker's mark: Miriam Hanid.

THE UK ASSAY OFFICES

London Birmingham Sheffield Edinburgh

The UK Assay Offices of London (leopard's head), Birmingham (anchor), Sheffield (Tudor rose) and Edinburgh (castle).

2. The fineness mark: this identifies the precious metal content of the article. The fineness is indicated by a millesimal (parts per thousand) number, and the specific metal type is indicated by the shape of the surround.

There are also two optional marks that can be applied alongside the mandatory ones:

1. The traditional fineness symbols: each precious metal has a specific image/symbol to accompany the millesimal mark.

Fineness mark. 925 parts of pure silver per thousand identifies sterling silver alloy.

The *lion passant* (a lion seen from the side) – the traditional fineness mark to identify sterling silver.

3. The Assay Office mark: this shows the assay office where the article was tested and marked. Currently, there are four assay offices in the UK: London (leopard's head), Birmingham (anchor), Sheffield (Tudor rose) and Edinburgh (castle).

Sterling Silver Sterling Silver Scotland Britannia Silver

Palladium Gold Platinum

Other fineness marks to identify silver, palladium, gold and platinum.

The leopard's head indicates the article was tested at The Goldsmiths' Company Assay Office in London.

Hand-struck sterling silver marks.

HISTORY, HALLMARKING AND ASSAY

Steel punches for striking traditional marks.

2. **Date letter:** this records the year in which the item of silverware was hallmarked. From 1999 onwards the date letter was no longer compulsory, but it is still advisable to include it. The date letter changes on 1 January every year.

Date letter 'G' for the year 2005.

 2008 2009 2010

 2011 2012 2013

Date letters for other years.

Compulsory and optional laser marks.

Silver marked at the London Assay Office with the Queen's Jubilee mark.

Compulsory marks.

Other hallmarks accepted in the UK

The UK has been a signatory to the International Convention on Hallmarks since 1972. This means that UK Assay Offices can strike the convention hallmark, which will be recognized by all member countries in the International Convention. Similarly, convention hallmarks from other member countries are legally recognized in the UK. Articles bearing the convention hallmark do not have to be re-hallmarked in the UK. Some national hallmarks from other countries are accepted in the UK without the need for further hallmarking.

A set of convention hallmarks.

A set of convention hallmarks.

Hallmarking – starting the process

This is a very straightforward procedure and you can register at any of the four UK assay offices. Once you have applied for registration, your own and unique maker's/sponsor's punch will then be made so that items you submit for hallmarking can be attributed to you or your company by this mark, and for generations to come. Your maker's or sponsor's mark can be struck by you before you submit an item for testing and hallmarking, or the assay office can keep your punch to strike your mark when they apply all the relevant hallmarks. If using the laser facility, understandably all marks are cut at the assay office. Your work for assaying can be hand-delivered using a personal counter service or posted to the assay office at which you are registered.

Universal and sound advice when you begin submitting your work for traditional hallmarking is always to present it in an unfinished condition – that is, before the refining and final finishing processes in preparation for polishing have been done. However, it is worth taking the area where the hallmarks are to be applied to a water of Ayr stone finish, and even pre-polish this to avoid any damage to the newly applied hallmarks as and when you take your piece to full completion, inclusive of polishing. By contrast, your work for laser marking needs to be presented for assay and marking either in a pre-polished condition or completely finished.

The traditionally struck/stamped hallmarks will create a raised bump after stamping because the metal is displaced from the indent of the punch into the metal. This needs to be carefully dressed down and dispersed but great care needs to be taken not to damage the hallmarks. This procedure is called 'setting down'.

Hand-stamped marks at the London Assay Office.

■ HISTORY, HALLMARKING AND ASSAY

Hallmarking at the London Assay Office.

Hand marking at the Assay Office, London.

Other quick tips:

- Surplus solder should be removed before assay testing.
- Clearly mark where you want to have your hallmarks applied on your design, and make sure you leave any special instructions written on the assay forms that you include with your piece to be tested and marked (for example, 'Please do not scrape on specific areas indicated because these are difficult to access for finishing after assay and marking.').
- It is also possible to include some sample pieces of silver that have come from the sheet that you have fabricated your design, in order to avoid scraping and possible damage to the actual piece.

Marking by fly press at the Assay Office, London.

HISTORY, HALLMARKING AND ASSAY

The assay offices provide useful information regarding assaying, hallmarking and the many services and facilities that they provide, and we have found staff to be helpful and supportive. If you are unsure about anything, ask for assistance to ensure that your specific objectives and requests are met. (See Further Information for contact details for the UK assay offices).

(All images in this section are by kind permission of the Goldsmiths' Company London Assay Office.)

Date letter marking at the Assay Office, London.

Laser marking at the Assay Office, London.

Silversmith Brett Payne forging.

CHAPTER TWO

MATERIALS, TOOLS AND EQUIPMENT

Materials

Today's silversmith is somewhat spoilt for choice when it comes to the supply and availability of precious metals for use in manufacture. The range of products is comprehensive and caters for most if not all of our current requirements. In addition, you can also order specific sizes, gauges, shapes and profiles for those one-off situations when individual design requirements must be met. The information below covers the main metals that are used in silversmithing.

Precious metals

The grades of silver listed below are available from bullion suppliers, along with an extensive range of carat golds, platinum and palladium.

Sterling silver

This is the most commonly used silver by most silversmiths; it is also known as 'standard silver' and contains 92.5 per cent fine silver mixed with other metal alloys representing the other 7.5 per cent (usually copper). Other alloyed metals sometimes partially replace the copper, usually with the intention of improving various properties of the basic sterling alloy, such as reducing casting porosity, eliminating firestain/firescale (*see* Chapter 4) and increasing the silver's resistance to tarnish.

RIGHT, ABOVE AND BELOW: **Various forms of bullion available. (Images courtesy of Cooksongold)**

MATERIALS, TOOLS AND EQUIPMENT

Britannia silver

This is softer than sterling silver and is used in situations where the demands on the metal are more severe, such as large, deep and complicated shapes for hand raising or spinning. Because of the higher content of fine silver (95.84 per cent), Britannia is less likely to crack and fracture during manufacture; as with sterling silver, the balance of alloy within this lovely quality of metal is normally copper.

Fine silver

This is 99.9 per cent pure silver with no alloy added, and although it is generally too soft for producing functional objects some silversmiths choose to work with fine silver, especially if extreme demands are to be placed on the metal throughout manufacture. However, we should mention that if you decide to use this pure metal you will need to consider designing your piece to compensate for its softness by increasing the gauge, also ensuring that the form and structure support your design.

Condiments made in Britannia silver by Gemma Daniels.

Folded vessel by Clare Ransom.

MATERIALS, TOOLS AND EQUIPMENT

Base metals

Gilding metal

This is a copper alloy, comprising 95 per cent copper and 5 per cent zinc. It is used as a base metal alternative to silver. Its working properties are very similar and it is ideal for starting to learn the core techniques and processes of silversmithing without incurring the higher cost of silver. Gilding metal is also receptive to silver plating, so your time invested in producing some work in this base metal will provide a very good alternative silver artefact at a moderate cost.

Copper

Like fine silver, this can be used to manufacture items if the same principles are applied, with the obvious benefit of saving you the higher cost of buying silver. You can also do vitreous enamelling on copper plate, so it is a sensible metal to choose when learning about another specialist technique of the craft.

Brass

Brass is a very useful hard base metal; it cuts, turns and finishes well when used on an engineer's lathe. It is also used for making spinning chucks, as well as in the technique of spinning. Brass holds a crisp edge when sawing and filing and also polishes very well. Standard modern brass is 67 per cent copper and 33 per cent zinc. However, soldering can be difficult and sometimes silver plating struggles to adhere or strike to the brass, so please be aware of these potential issues.

Bronze

Bronze is available on the market in a wide range of grades; sometimes these are used for casting and fabrication, and also where patination is required to finish a design in base metal.

Other materials

Stainless steel

This is valued for its structural strength, hardness and durability, and it can be used in conjunction with silver but this has to comply to the current hallmarking rules (please check with your local assay office). It can also be used for making durable templates and patterns.

Silver chandeliers by Padgham & Putland, using a stainless steel skeleton.

MATERIALS, TOOLS AND EQUIPMENT

Tea set by Richard Gamester on wooden (wenge) base.

Wood

Many hard and tropical woods are used in silverware. Lignum vitae, mahogany, beech, rosewood, padauk, oak, pear, African blackwood and many others can be used as bases of vessels, trophies and models, as well as for handles, insulators, decorative features and the like.

MDF

MDF is used for making trophy bases because it is a stable material and will hold and retain the shape it has been formed into; it is also very tolerant of different temperatures. Once fabricated and moulded it is then professionally sealed and sprayed with either paint or a polyurethane lacquer to achieve a high-lustre polish.

Model by Padgham & Putland, on a highly polished polyurethane base.

MATERIALS, TOOLS AND EQUIPMENT

RIGHT AND BELOW:
Roulette wheel by Padgham & Putland, using bird's eye maple veneer.

Glass

Glass is used in sheet and blown form. It can serve as a functional element within a design and is also valued for its visual and aesthetic qualities. Glass can be used for bases, as a component part of a design, for holding liquids – water, wine, juice and so on. It is universally popular, it remains a contemporary material and supports and enhances good design aesthetics.

Wood veneer

Burr walnut and bird's eye maple veneer are just two examples of the many wood veneers available, usually covering an MDF base or substructure.

RIGHT: **Claret jugs by Martyn Pugh.**

MATERIALS, TOOLS AND EQUIPMENT

Steel: mild, silver and tool

This is widely used for making supportive components in manufacturing silverware on things like formers, spinning chucks, tools and jigs, punches, etc.

Cast iron and steel

These are predominately used for the casting or making of stakes for hand raising, seaming work, bespoke shapes and supporting tools when fabricating silverware designs. Many silversmiths make patterns in wood or MDF for stakes to be cast at a foundry. This requirement and activity incrementally helps you to build a good collection and range of stakes that will cater for all sorts of shapes and sizes that you will need for the variety of challenges and demands in manufacture. Such a collection will also save you a lot of money in comparison to retail prices for such tools.

Stone

Natural materials such as solid granite, marble or travertine are a good choice of material for bases of trophies, models and designs. The quality finish that is obtainable from such materials and its associated weight make them a good choice if funding permits; they are a natural partner to silver and work particularly well together.

Workshop stakes.

MATERIALS, TOOLS AND EQUIPMENT

Stone veneer

As an alternative, stone veneer is best used on a pre-formed aluminium base, and this has the obvious advantage of reducing the cost in comparison to solid stone. Semi-precious minerals such as lapis lazuli, malachite and other fragile and more expensive materials are also used in this way for commercial reasons.

Tools

Compared to jewellery making, a silversmith needs a larger range and scale of tools, equipment and machinery, and this

Malachite veneer by Richard Fox.

The hammering room, The Goldsmiths' Centre.

ABOVE AND BELOW: **The silversmith's workbench.**

Stakes – Padgham and Putland.

MATERIALS, TOOLS AND EQUIPMENT

Hammers and stakes for raising.

Equipment and machinery

The equipment and machinery required is associated with most of the higher costs, as one might expect, but again, there are companies who specialize in buying in and selling on some fine quality products that are in very good working order, usually at moderate cost. You should carry out careful research when equipping your workshop, and it is also advisable to plan ahead, estimating where you think you might be in a few years from starting out, in terms of space and what you might need as you progress and develop your practice.

(The images in this section are courtesy of The Goldsmiths' Centre.)

of course will also take up greater floor and workshop space. Equally, the potential to generate more noise from your activities is a reality, so you should bear this in mind when deciding on where your workshop location will be. It is difficult to provide an ideal shopping list of the things you need because the requirements will vary depending on the nature of the work being undertaken.

However, the selection included below gives an insight into what could be considered necessary in a well-equipped silversmith's workshop. We are also mindful of the relevant costs involved but many of the things you need can be purchased second-hand, sourced from trade magazines, eBay or from silversmiths who have retired, perhaps, and want to pass on their heirlooms at moderate prices. This route is recommended; it is what most of us do when starting out in silversmithing.

Turning, cutting and drilling.

Engineer's lathe.

Pickling and cleaning.

44

MATERIALS, TOOLS AND EQUIPMENT

Annealing and soldering.

Scratchbrushing.

Sheet and wire milling.

Cutting sheet and wire.

Milling and cutting.

Puk welding in process.

Fume extraction.

45

The workplace.

CHAPTER THREE

HEALTH AND SAFETY

The making and finishing of silverware, like many crafts and manufacturing industries, carries potential hazards and dangers. You need to be aware of, and alert to the potential dangers of, the tools, equipment, machinery and chemicals that you will use and come into contact with in your work and in the workplace.

Keeping everything clean, tidy and in a good condition goes a long way to help you maintain a safe working environment, but it is also your own responsibility to instigate and implement a good code of conduct in the workshop environment. Whether you are a designer maker working independently, sharing workshop spaces or employed, the rules and regulations of health and safety apply equally to everyone. We are all responsible for creating a hazard-free area and environment in which to work. This short but very important chapter aims to give you the most up-to-date information about health and safety in the relevant areas. This is done in a simple and user-friendly manner to enable you to accept, absorb and utilize the information to ensure that you operate safely, both for yourself and for others around you.

Keep it legal!

Health and safety codes of practice, their rules and regulations may seem rather onerous and burdensome but they are a legal requirement and must be adhered to; non-compliance could get you into all kinds of trouble and possibly result in serious litigation. Creating a set-up that complies with all the health and safety regulations could save you from accidents, injury, heavy costs and legal pitfalls. Getting things right can be a logistical minefield, but there's so much help available out there that you can be health and safety compliant without losing your ability to operate as a creative and effective designer.

Start by going to the Health and Safety Executive website (*see* Further Information) to download 'Health and Safety Law – What You Need to Know and Health and Safety Regulation'.

Safety Signs – Colour and Shape

There are various safety signs, ranging from the familiar 'no smoking' and 'fire exit' to more specialized signs – hazard warnings (yellow triangle with a black border and a pictogram), prohibitory signs (white with a red border and diagonal line and a black pictogram), mandatory notices (blue circle with a white pictogram), safe condition (green rectangle with a white pictogram) and fire equipment (red rectangle

Symbol advising of hazards.

HEALTH AND SAFETY

Prohibitory symbol.

Sign advising of safe condition.

Mandatory symbol.

Fire equipment.

with white pictogram). Each sign may have an appropriately coloured rectangle under it bearing an explanatory legend.

Getting the basics right

Utilities

Gas, electricity and plumbing are the framework of any studio/workshop. The regulations and legislation are continually changing, but the one rule about utilities is that all work **must** be carried out by qualified professionals.

- All electrical work must be carried out by a qualified electrician who is a member of a Competent Person Scheme through the Government-approved registration body, NAPIT (National Association of Professional Inspectors and Testers). These qualified people will certify that their work will comply with building regulations.
- Plumbing work must also be carried out by a qualified plumber who is registered through NAPIT.
- By law (The Gas Safety [Installation and Use] Regulations, 1998) all work with natural gas fitting and appliances must be performed by a qualified engineer who is on the Gas Safe Register. Portable or mobile gas equipment brings its own dangers. For advice on safe

use, cleaning and storage go to the Health and Safety Executive website to view their guide – Safety in Gas Welding, Safety and Similar Processes.

Extraction – make it safe

Strict regulation applies to areas where fumes and dust are created as part of the workshop process. Equipment suitable for the safe removal of fumes or dust **must** be used particularly during the following processes:

Welding, soldering, burning, cutting, polishing, etc
Using a shot/bead blasting machine
Using woodworking machinery (including portable equipment)
Machining of ceramics, carbon or other materials which may cause a fine dust.

Advice on Local Exhaust Ventilation (LEV) Workplace Fume and Dust Extraction can be found on the HSE website.

Writing risk assessments – know your hazards

Don't ever feel that carrying out a risk assessment is lost time away from the design and manufacturing process. So many procedures in the workshop carry a risk, and an assessment must be undertaken on all operations and processes identified as such. The risk assessment identifies the hazards, any rules and regulations surrounding the process and any controls which need to be put into place. Copies of these assessments should be available in the workshop and users **must** familiarize themselves with the risk assessment before starting work.

Risk Assessment and Policy templates can be found on the HSE website.

Making COSHH Assessments

By necessity, every workshop contains potentially dangerous materials and being aware of these inherent dangers is vital. The Control of Substances Hazardous to Health (COSHH) regulates all materials which might be dangerous to the user or others in close proximity – such as acids, solvents, chemicals, powders and enamels to name just a few. Details of the nature of the substance should be obtained (usually in data sheet form from the manufacturer) and if thought to be hazardous, a COSHH form should be completed, with detailed information about the nature of the substance, kept on file in an accessible place for all users, who **must** read it before starting work.

The HSE website has a downloadable leaflet called 'Working with Substances Hazardous to Health – What You Need To Know About COSHH'.

Working safely – be on your guard

The majority of workshop machines are fitted with guards and other safety devices designed to prevent access to dangerous moving parts of the machine. It's tempting to remove guards from pillar drills, lathes, grinders, etc. to 'save' time and effort, but the risks far outweigh any short-term gains.

While you have the responsibility to ensure that all guards are in place, it must be emphasized that any person who causes an accident by wilfully tampering with, removing or not replacing a guard is liable to prosecution under the Health and Safety at Work Act 1974 (sections 7 & 8).

For more workshop safety advice go to the HSE website and check out the Simple Guide to the Provision and use of Work Equipment Regulations 1998 (PUWER).

Protect yourself – accidents do happen!

Could you still work with a couple less fingers or maybe an eye? Sorry to put the frighteners on you, but personal protection should be taken seriously. Grinders, polishers and guillotines can all be replaced – you can't!

- Workshops should be regarded as 'eye protection areas' and each permanent workshop user must be supplied with personal safety spectacles or goggles. They must be worn whenever flying chips, swarf, turnings, coolant splashes, etc. might endanger the eyes. Eye protection should also be given to visitors where necessary.

HEALTH AND SAFETY

- Everyday clothes should be covered while working in mechanical workshops. Smocks are fine if they are in good condition and fit closely at the wrists but boiler suits are safer.
- Prolonged contact with oil, grease, cutting fluids, etc. can cause skin problems. Barrier and cleansing creams should be available in all workshops and protective clothing must not be allowed to become heavily soiled with oils, etc. Launder protective clothing regularly.
- Long hair can be caught in moving parts of machinery – keep it tied back and secured.
- Wearing rings, dangling jewellery (neck chains, earrings, etc.) is very dangerous – remove them before working.
- Suitable gloves should be worn when handling rough, sharp or dirty objects. However, gloves should never be worn near or using rotating machinery, as this can be very dangerous!
- Protective shoes or boots **must** be worn by those involved in heavy lifting, with strong soles to prevent feet from upward damage. Sandals and other lightweight footwear should **never** be worn in workshops!
- Workshop users and visitors must wear suitable ear defenders or disposable earplugs near a source of loud/prolonged noise – particularly if it is over 85dBA.

Every workshop should maintain a first aid box which should be checked and restocked on a regular basis. For more information see 'A Short Guide to Personal Protective Equipment at Work Regulations, 1992' on the HSE website.

Chemicals – handle with care

Whether storing, using or disposing of them, chemicals come with their own unique menu of risks and regulations. Never, repeat never, when setting up a workshop or introducing them into this environment, do anything without gaining in-depth advice from a professional. Because getting this wrong puts everyone at risk! Here are a few important warnings and some useful signposts to getting the best advice.

Storage

When not in use, containers of flammable liquids needed for any current work should be kept closed and stored in suitable fire-resisting cabinets or bins sited away from the work area and not hinder escape routes. Flammable liquids should be stored separately from other dangerous substances that may increase the risk of fire.

Use

Solvents, oils, cutting fluids, cleaners, etc. should always be kept in marked containers, and never in jars, tins, bottles or other containers. Care should be taken not to mix solvents from different groups in the same tin.

Disposal

Solvents should be disposed of in properly labelled containers. Waste cooling/cutting fluid must also be disposed of in the same manner – and **never** poured into a drain.

More advice on the storage and disposal of chemicals and chemical waste can be found on the HSE website. See also the Hazardous Waste (England & Wales Regulations 2005) at www.legislation.gov.uk.

HEALTH AND SAFETY

A selection of signs that might need to be displayed around the silversmith's workshop.

Hand raised beaker by Padgham and Putland.

CHAPTER FOUR

MANUFACTURING TECHNIQUES, METHODS AND PROCESSES

The hand raising process

Raising is a hammering technique used by silversmiths to form seamless objects from flat pieces of metal sheet into full-bodied, three-dimensional shapes and sizes; any shape can be raised by using this age-old, timeless and irreplaceable technique. Its origins and values have remained relatively unscathed throughout the development of silversmithing, and hand hammering remains the foundation of forming metal. All other methods of manufacturing seamless vessels follow and build on this essential process. It has been practised by the Egyptians, Greeks, Romans and many other civilizations throughout time and history, and it remains one of the most challenging, exciting and satisfying experiences to learn and master of all the silversmithing skills. It is here you will really understand about metal, its characteristics and working properties.

Spinning, as an alternative and production-led method to achieve seamless 3D shapes, is used in the industry, and is a very cost-effective way to produce accurate 3D pieces in quantity. However, this cannot match or challenge the strength, effect and unique properties that hand raising always offers.

Design

Once you have designed your piece you will need to produce working (line) drawings that help you define the exact dimensions, scale and size of your design through side and plan elevations, as illustrated. From this you can then calculate the diameter of the metal disc that you need. This is commonly known as a 'circle blank' and it is the diameter dimensions that you will need to quote when ordering your metal blank for raising. Alternatively, you may prefer to buy a square of sheet and cut your circle out from this (but you would obviously be buying more metal which will also increase your initial outlay for the project).

Blank size

To determine the diameter of the blank you need to take the average diameter of the piece to be made and add this to the total height of the vessel. For almost all shapes this is sufficiently accurate but as you gain experience you may increase or reduce the diameter based on your final shape, complexity of your design, the metal gauge selected, your technique, and of course, your growing confidence in hand raising.

Thickness and choice of metal

Now you have your blank size you can decide what thickness of metal that you need for hand raising your design; this is based on several factors. For large items and shapes that have a high demand on the metal you will need to select a heavier gauge, 1.2mm or 1.3mm for example. For deep raisings and difficult shapes Britannia silver should be used because of its higher content of pure silver, offering greater malleability in manufacture. As before, a 1.2mm or 1.3mm thickness is sensible in order to hold its shape against bruising or denting through all stages of hammering. This also applies to the wear and tear that any hand raised vessel can face over its domestic life.

When using sterling silver, 1mm and 1.1mm gauges are appropriate and sensible thicknesses for most requirements,

MANUFACTURING TECHNIQUES, METHODS AND PROCESSES

but the cost of the silver may determine your final decision. However, it is worth balancing this outlay against the many hours of skilled labour needed to manufacture and perfect your design to completion, and if you cut your initial costs by going for a thinner gauge your work and efforts may be wasted in the end result.

If you intend to use a base metal instead of silver, gilding metal is the best substitute because its working properties are close to silver; this is infinitely better to use than copper, which is too soft by direct comparison.

It is feasible to raise shapes in fine silver and copper, but as already described with Britannia silver, you will always need to select thicker gauges when hand raising, and extra care and attention will be needed to ensure that your final design will be taken to full completion in a work-hardened condition (no annealing will take place in the concluding stages of hammering) to hold its shape and strength, because left in a softened state your design will easily bruise, dent or become misshapen.

Always buy new metal sheet from a recognized bullion dealer, and certainly do not be tempted to smelt down any of your scrap silver to use for raising. This never works: the metal cracks and your well-meant intentions, energy and efforts will come to nothing in the end. Any experienced silversmith will give this advice, which will always save you time, money and frustration. You will find a good selection of bullion suppliers listed in the Further Information section of this book.

Annealing

Fabrication of an item in gilding metal or silver by any of the normal cold forming processes will progressively work-harden the metal as the amount of deformation increases and the crystalline structure of the metal becomes increasingly disturbed. The amount that the metal will tolerate before thinning and cracking occurs is limited; therefore it will become necessary during the making process to periodically re-soften the metal by 'annealing', that is, heating the metal to a temperature at which the work-hardened material reverts back to its malleable and original condition.

It is essential to anneal your work at appropriate points throughout the forming process when engaging in hand raising; this also applies to all methods of hammering and forming metal in silversmithing.

Firestain

Sterling silver is alloyed with copper, and firestain occurs when untreated surfaces are heated during annealing or soldering using a gas torch on an open hearth. Copper oxides form just under and on the surface of the silver, producing a purple stain on part or all of the surface of the metal. This is undesirable and particularly so when finishing your design leading up to and including polishing.

The more times the silver is heated the deeper the firestain penetrates but this can be reduced using a protective coating applied before each heating process. The product Argo-tect is readily available in powder form and is mixed to a paste with water or methylated spirits and applied using a paintbrush. Extra attention should be paid to the correct temperatures when heating your silver, because with the Argo-tect applied

Painting the piece with Argo-tect protects against firestaining.

Annealing.

it is harder to see the colour changes that you need to achieve when annealing or soldering.

It is generally advisable to anneal after each course of blocking or raising. Gilding metal and silver can readily be softened by heating for about one minute in a temperature range of 600–650°C, i.e. when the metal is at a dull, cherry-red heat. Place your circle blank on a clean hearth turntable, or alternatively a heat-resistant flat fibre board.

If you have done one blocking process that already gives some shallow form, place this downwards showing the convex shape. Now using a gas torch, preferably a unit with natural gas and compressed air, or pressurized bottle propane, create a large and soft bushy flame, and gently heat up the metal, slowly revolving the turntable to ensure that even heating occurs.

Silver and other metals have a subtle colour change during annealing that is best seen in a dimmed or darkened hearth area. Early learners are advised to experiment with small pieces of silver to determine by colour when the metal is approaching this critical temperature.

The relationship between the temperature during annealing and the time spent doing this is very important, and this must be carefully controlled to achieve optimum and consistent results to ensure that the metal stays in perfect condition throughout manufacture. Exceeding 650°C can cause excessive grain growth in the metal structure and this produces an orange-peel type condition when the metal is subsequently worked. This needs to be avoided because it will increase the degree of difficulty and reduce the quality of finish on the metal surface.

The metal may be quenched after annealing once it has been cooled to below 500°C, i.e. when the metal has cooled to black heat colour. Using tongs, grasp your blank and plunge it into a sink or bucket of water large enough to ensure that you can get instant and complete immersion. Always leave your piece long enough after the heating process to ensure that it has cooled sufficiently because quenching from higher temperatures may cause distortion and even cracking. Overworking gilding metal and silver, as well as incorrect or incomplete annealing through several fabrication stages can produce a hard, springy metal which will be very difficult to work and subsequently form. If using gilding metal you will need to fully soften your blank by annealing before any forming stages commence because this metal is usually supplied in a half-hard condition when you purchase it.

Pickling

After quenching in water, carefully place your work into a pickling solution to remove any oxidation from the annealing process. This will return the metal to a clean surface condition free of any impurities and ready for you to continue working the metal. We recommend using a safety pickle, a product available from Cookson (see Further Information). This powder compound mixed in water works very well when heated and doesn't emit any hazardous fumes. For reference, the traditional cleaning solution used for pickling is sulphuric acid with water, but it is advisable not to use this because it emits acid fumes.

Always immerse your work when cold into any pickling bath to avoid any form of spitting or reaction with the solution, and remember that the safety pickle has to be kept warm/hot to enable it to function properly in cleaning metal. Fully rinse in water and then thoroughly dry your piece to be ready to move on to the next stage. Your silver is now a matt white colour and when further hammering takes place with a polished hammer face, you can see every hammer blow, making it easier to achieve accuracy, control and symmetry.

Blocking

Before the actual raising process begins you will need to hammer your metal blank into a shallow dish, a technique called 'blocking'. Firstly, to find the centre of your blank (on both sides) use your dividers to lightly scribe four arcs equally spaced from around the circumference; this will create a small square area from the divider arcs to be able to locate the exact centre of the blank. If the centre space is a bit big to mark the centre accurately, scribe more arcs that reduce the centre space to make this task easier. Now make a mark in the centre with a scriber, sufficiently visible to be able to position your pencil compass.

Using your pencil compass, mark a series of concentric circles to act as guide lines from the centre to the outside edge of your blank, spaced about 20mm (¾") apart. We use a pencil compass because steel dividers would score the surface, and these lines could open up, and even form into cracks as hammering continues. Now using a pencil, draw a straight line from your centre mark to the outside edge. This is your start and finish line for each circle.

The blocking process is traditionally done into a wooden tree trunk (a hard wood is preferable) that stands on the floor

MANUFACTURING TECHNIQUES, METHODS AND PROCESSES

Finding the centre of the circle.

A wooden tree trunk is used for the blocking process.

at about 1.2m high. The top of the trunk has a series of carved hollows and grooves used for various sinking procedures. Wood is specifically used to avoid any stretching or marking of the metal. A hollow, 10cm (4") in diameter and 3cm (1¼") deep, is used for the blocking process. If you do not have access to a wooden tree trunk, you can use a large leather sandbag for the blocking process but this is a second-best option, and should be used only if you have no alternative.

For anyone beginning this process they should use a blocking mallet, and then subsequently progress onto a blocking hammer once more control and experience is gained. Place the outside edge of your blank over the hollow in the wooden trunk and holding the opposite edge, begin to mallet the metal onto the wood, turning the blank after each hammer blow until you have completed a circle. As with all hammering in the process of raising, it is preferable to rotate the piece towards the hammer blows to give you a good view of your work in progress and achieve the greatest control. Try to keep your hammering within these circles as precisely as possible because this will lead to even and concentric forms as you progress. Now continue to the next circle towards the centre of your blank and repeat this process until you reach the centre.

ABOVE AND BELOW: **The initial stages of blocking.**

The first stage of blocking is now complete.

The metal will now be in a work-hardened condition and in need of annealing; this process returns the metal to its original level of malleability in preparation for the next stage of forming. After the first stage of blocking you will now have a shallow bowl. It is necessary to block your blank a second time, and maybe even three times, depending how much you move the metal in each stage and also whether you are using a wooden mallet or metal hammer. Once you have a bowl shape you are now ready to progress onto the raising stage.

MANUFACTURING TECHNIQUES, METHODS AND PROCESSES

Caulking

Depending on your design you may wish to have a thickened top edge on your raised vessel. This is usually desirable, as it gives your hammered vessel greater strength, presence and authority, and always looks more complete and correct in the finished article. This process is called caulking and is achieved by hammering down onto the edge thickness of your raising and is normally applied after each course of raising.

Remarkably, this process can substantially increase the thickness of the metal at its leading edge, for example, a blank gauge of 1.2mm can be increased to 4–5mm at the top edge on an average-size raising. This process takes a great deal of care and careful hammering.

Caulking can begin before you start blocking.

Using the rounded end of your raising hammer, caulking can begin before you start blocking, even when your metal is flat. Place your blank into a sawn groove in a hardwood block that is firmly clamped in a vice, or in a groove created in your tree trunk. Now hammer the silver at a right angle to the edge of the blank. Closely controlled hammering is required, overlapping the previous hammer-blow as you travel round the circumference of the blank. Once you have completed a round of caulking, use the flatter, 'raising' end of your hammer to set down or flatten out the marks left from the rounded end of your raising hammer. This has two effects: it keeps your edge flatter, and it increases the caulking thickness. It is essential to hammer the edge evenly at every round of caulking to keep the top edge flat and even.

After every caulking stage, the edge of the metal will have a slight flare; this needs to be set back to prevent the edge from mushrooming over and cracking. This is done by using

Setting first caulking.

Caulking after blocking.

Caulking after first raising.

Setting the edge.

MANUFACTURING TECHNIQUES, METHODS AND PROCESSES

Caulking during raising.

Setting the edge during raising.

A range of hammers and mallets.

A range of stakes.

the rounded end of your planishing hammer over a curved stake. It is important to apply the correct hammering force: too little will still leave a flared edge; excessive force will take out any thickness achieved from the caulking. Once you have set the edge, anneal your silver. To achieve a good thickness from caulking this process should be done after each blocking and raising stage.

Raising

Refer back to your line drawings. If your design has a flat base, mark with pencil compass lines the diameter of this on the outside of your bowl, this time at 12mm (½") intervals. Also with a pencil, draw a straight line from the centre point to the outside edge on the exterior of the bowl; as before, this is your indicator for methodically starting and finishing each course of raising. As your confidence and skill in hammering and raising develops, you will want to take your knowledge, skills and capability further (details on advanced raising are included later in this chapter, in the section on Raising with Crimping/Creasing).

The steel or iron tools upon which the raising and all hammering takes place are called stakes. For the first stage of raising, a double-ended stake is usually used, and this is best secured in a tree trunk (as previously mentioned) or

Bouging and planishing stake.

MANUFACTURING TECHNIQUES, METHODS AND PROCESSES

sturdy bench, providing a comfortable sitting position for hammering.

Alternatively, the same stake can be tightened in a leg vice or engineer's vice, and the entire raising process can be done in a standing position. All edges of this stake need to be soft and rounded, and the top surface convex. You will use a raising hammer; this will also need to have soft, rounded contours on all edges so that if you strike the metal with the edge of the hammer it will not cut, crease or excessively thin it.

The positioning of your silver on the stake for all hammering procedures is very important, and this takes time, practice and experience to master. If the position is not correct at any of the hammering stages your raising will become uneven, misshapen, and inaccurate, and will not be true to your design dimensions.

Of equal importance is your posture and position when hand raising. Whether standing or sitting, as you hold your hammer your forearm needs to be close to your side and positioned parallel to the floor, at a right angle to your upper arm. Your raising hammer should be seen as an extension of your hand, forming a straight line from your elbow to the hammer head. Hold your hammer in a firm grip near to the bottom end of the handle so you get the full effect of the weight and force of the hammer head. Some silversmiths prefer to place their forefinger along the hammer handle to increase the accuracy of each hammer blow. A fully balanced, correct and comfortable position will give you every opportunity to hammer accurately and proficiently, and to achieve the right results.

Place your silver onto the stake with the hammering hand a few centimetres above the stake, the hammer head about 12mm (½") above the point at which the silver is touching the stake on the underside. Tip the metal back so that the outside edge is just a few centimetres above the stake. As you strike the hammer onto the silver about 12mm (½") above your first pencil line it is the front edge of the hammer that will first strike the silver, and as this force continues downwards the silver is pressed through the air space and down onto the stake.

It is the force of the hammer coming into contact with the stake, causing the metal to be compressed, which is vital to successful raising. If your hammer blows are too hard the metal thins; equally, if they are too soft your raising shape will not be kept under control. As before, practice and experience will help you to find just the right strength and force of hammering that will result in the correct shape, size and proportions that are necessary to achieve a gradual thickening of the silver as it is compressed. On smaller blanks (of about 20cm [8"] diameter or less), you can place the middle finger of your

First raising.

Continue raising.

Malleting the top edge.

hand holding the silver against the stake underneath the bowl to act as a rest to help with consistent positioning of the silver onto the stake.

It is very important to keep this first circle of raising neat and fully under control and make sure that you don't try to force the metal down and in too quickly. This is tempting and easy to do but it leaves a big step for your next circle of raising, and this can lead to an uncontrollable situation, where the next circle of hammering may cause the metal to fold and form cracks.

By fully controlling your raising as you progress through every stage of hammering you will achieve a reduction in the top diameter of your design of about 12mm (½") after each course of raising.

Progressing onto the next circle of hammering, bring the silver back onto the stake so you are hammering on the same area each time. When you are about 12mm (½") from the top edge of your bowl, use your raising mallet to finish off the course. This will allow you to 'tuck' the top edge in as much as possible without the risk of the steel hammer squeezing the edge too much and excessively thinning it. Your raising will now need annealing. After pickling and drying, redraw your pencil lines, but this time start half-way further up the bowl from your first course. This is because each time you start a course of raising the hammering action on the first ring kicks back the metal where it touches the stake, and if you were to start from there every time, you would excessively thin the metal at this point, so we alternate the starting position at each course of raising.

Inspecting the raising marks.

At the end of each circle of raising, look inside your bowl. You should see the points at which the silver has been trapped between the hammer and the stake, showing as a ring of bright circles for each circle of raising. Therefore, the inside of your bowl should be covered with neat rings, resulting in the piece being round and true.

This process will need to be repeated four or five times. After each course, the sides of your piece will become progressively steeper as the height and shape of your vessel increases and slowly but surely begins to match your design.

The reason you raise your piece to the exact size and shape is so you can bouge it (discussed later in this chapter); this reduces the size slightly, then one or two planishings will stretch and expand it back to the pre-bouging size and shape.

Once the raising is taken to parallel upright sides, for this design we need to block the base out to give us a more rounded form. The next stage is finishing the bottom corner shape. This can be done using a mallet after choosing a correctly shaped stake.

A profile template is now required to complete the raising stage to ensure that the true shape of your design is achieved. This can be made from 1mm thick metal or plastic.

Taking the same stake that you last used, start raising from above the widest part of your design, and continue until you reach the narrowest section. Keeping with the same stake, reverse your position and direction of hammering, tipping the silver up towards you, resting it on its top edge. Raise as before but this time towards the narrowest section where your raising previously ended. You should now have reduced the diameter at the middle point of this section. Keep repeating this process until you have reached the correct shape to match your template.

MANUFACTURING TECHNIQUES, METHODS AND PROCESSES

The blocking courses.

The raising process.

61

■ MANUFACTURING TECHNIQUES, METHODS AND PROCESSES

1. Monitoring the raising process.

2. Raising in.

3. Further on.

4. Nearly done.

5. Starting a new course.

6. Carefully finishing the course.

7. Another new course.

8. Continue raising in.

MANUFACTURING TECHNIQUES, METHODS AND PROCESSES

9. Concluding the caulking.

10. Checking for trueness.

11. Blocking out the base to give a more rounded form.

12. Annealing.

13. Raising in.

14. Back raising.

63

Bouging

The main reason for employing the technique of bouging is to flatten out any marks incurred after the raising stage is completed. Inevitably, the force of hammer blows used in shaping the metal when raising will have put marks into the metal. If left, these can be difficult to remove when planishing, which is the final stage of hammering on your hand raised object.

Bouging.

Bouging is like a finer version of raising and serves as a good bridge before planishing commences. Having achieved your exact shape through raising, the bouging process can begin. Use the rounded end of your raising hammer and follow concentric lines 12mm (½") apart marked with your pencil compass from the base centre point on your metal to achieve and maintain accuracy and uniformity. Remember that if done correctly, bouging will remove all of your raising marks, and precise and controlled hammering is required to achieve this. Unlike raising, bouging is controlled by wrist action movement and not elbow movement. Lifting your metal 1–2mm off the best fitting stake you used when raising (probably the same one you used when finishing the raising process), begin hammering, still slightly raising the metal inwards, but overlapping every hammer blow with enough force to smooth out your raising marks. This applies to inside and outside surfaces, because they are equally important.

Once you have completed the first circle of bouging, inspect both sides of the vessel to see that you are using sufficient force to completely remove the raising marks. If you can still see some, you will need to increase the force of your hammering onto the metal. As you progress, the next ring of hammering must overlap the previous one so you achieve a flat finish both inside and out. It will look like a heavy planished finish with deeper marks caused by the rounded end of the raising hammer. This process is repeated until you have fully covered the area and have achieved a uniformly smooth surface, suitable for planishing to commence. A well-bouged piece requires fewer plainishing courses to take the metal to the final smoothing finish in preparation for filing, stripping, pre-polishing and assembly where appropriate. It is worth reiterating the importance of tight and smooth hammering; it is not only more accurate but saves you time in refining and finishing your components, retains more metal in a piece and improves its inherent strength and durability.

Planishing

Planishing, the final hammering operation, smooths the silver surfaces by applying many closely and carefully aimed hammer blows. These need to overlap each other and this application will eventually result in an even, unbroken and smooth surface.

A round-faced planishing hammer is normally used in most cases, but concave forms and sharper angles will require a planishing hammer with a tighter profile, or even a collet hammer to reach and dress every part of a design. The head of the planishing hammer should always be highly polished, as well as the steel stake(s) that you will be using. This is of paramount importance because the final stage of hammering must not impart any marks onto your metal, either from the hammer head or the steel stakes you use. Selecting the correctly shaped stakes is also an important part of successful planishing, and your piece may require a number of stakes with varying cross-section profiles as you progress and endeavour to planish successfully.

Even more care should be taken when changing your stakes, because an incorrect stake will result in ridges and uneven

Planishing.

MANUFACTURING TECHNIQUES, METHODS AND PROCESSES

Planishing a concave area.

surfaces being created on an incompatible stake whilst hammering. This must be stopped and corrected immediately to avoid unnecessary marks that will only increase the time spent working on a piece. To avoid this, your stake should have a slightly smaller radius than that of your silver object being planished. Never select one that is larger because this would change the shape and size of your piece when hammering. Adopt the correct and comfortable standing stance that you used when raising and continue the same wrist movement used in bouging to deliver the hammer strikes. Mark your object with concentric pencil lines, again 12mm (½") apart. Placing the silver on the stake, press the hammer on the area to be planished, slightly releasing the grip of your silver with your holding hand.

This will position your silver to the correct place to begin planishing, and it is a lighter, more of a dressing hammering action that you need for planishing. You are looking to achieve a ringing sound as you planish, which will be the hammer making direct contact with the stake through the silver. If you are making a hollow sound, you have not made the right contact; this will dent the silver and affect the shape of your piece, which will of course, need correcting. After completing the first ring of overlapping hammer blows, take a look inside your piece to see the result. There should be an unbroken, smooth and bright ring of hammer facet marks showing. If you see any gaps between your plainishing marks, apply a little more force in the next ring of planishing. The second and subsequent rings should overlap the previous ones so you can see bright rings on both sides of the metal surfaces. Continue to the top of the piece, changing the stake where and when necessary, and then anneal your silver.

The planishing process may have to be done twice to achieve the outcome you need, with the second course being a lighter hammering application than the first.

'Cross planishing' is the final stage of planishing. Its purpose is to hammer out any small ridges or irregularities formed from the concentric overlapping rings of planishing, and this will leave you with a lightly hammered, very smooth surface that should be perfectly ready for filing and finishing.

When starting your cross planishing, move your hammer in an up-and-down motion overlapping previous rings of planishing marks/facets, slightly sweeping your hammer across the silver. Again, continue this motion and pattern right through to the top of your piece to ensure total coverage of the metal surface from this final hammering technique.

Filing, ready for polishing

After the final planish, the surface of your piece is covered in tiny facets. These can now be removed using a steel file, an effective tool for refining your metal surfaces in preparation for the next stage. Always use good quality files because they cut into the metal far better and the grooves/teeth don't clog up so quickly.

Filing the beaker.

The grade '2 cut' (second cut) is perfect for this task. Start by resting the file on the surface, and remembering that the file only cuts and works into the metal on the forward stroke, push the file following the contour of the piece. Lift the file off at the end of the stroke and start again next to the previous file mark. You will now see that your file marks are eliminating the planishing facets, and smoothing the surface of the metal. Continue filing until the whole piece is covered. You may need to change the file shape to be able to address all contours on your design as you progress over the total area.

Now using a '4 cut' (smooth cut) file, repeat the process, making sure you file in the diagonally opposite direction to your '2 cut' filing actions so you can clearly see you are eliminating all your previous deeper file marks.

MANUFACTURING TECHNIQUES, METHODS AND PROCESSES

RAISING A LARGE VESSEL

This sequence of images demonstrates the various forming stages taken when raising a large vessel. This illustrates how, in this instance, Wayne Meeten takes silver from flat sheet to create extreme form through hand raising.

MANUFACTURING TECHNIQUES, METHODS AND PROCESSES

'Cascading' vessel by Wayne Meeten.

The finished beakers by Padgham and Putland.

Pumice and Water of Ayr stone

These abrasive materials are the next step of refinement in preparation for polishing, and either of these natural compounds can be used to remove file marks or even take out hammer facets in areas that a file cannot reach or get to. Pumice is best used on flat or concave surfaces because it is good at blending out areas, making them flat and smooth. Water of Ayr stone is a harder material and can achieve an even smoother and finer finish than pumice. It is particularly useful when removing marks from small areas that are difficult to reach; you can easily file this stone to fit individual shape and size requirements, giving the best possible finish for achieving a high quality polish throughout (*see* Chapter 5).

Hand forging

The practice of hand metal forging is one of the oldest known metalworking processes, and traditionally this was performed by a smith simply using a hammer and anvil. Types of forging are classified according to the temperature the metal has been worked at and formed, i.e. cold, warm and hot forging.

As with the many aspects of hammering included in this book, to undertake and successfully master these particular techniques you need to learn and control the fundamental principles of hammering. Today there are very few designers who practise hand forging in silversmithing but we include some fine examples in this section to illustrate the beauty and refinement that forging can offer, and to show how well this technique has been developed and exploited by designer-maker Brett Payne.

Quite apart from its unique origins this particular aspect of specialist hammering still invites a designer to investigate the techniques to see if it suits their style and the type of design work they may wish to explore and develop. The number of craftsmen now practising the craft of hand-forged cutlery and other silverware is small, but this in itself creates opportunities for those who wish to develop a distinctive and specific niche in silverware design and manufacture.

Forging a spoon

The following set of illustrations, images and commentary shows the reader how to hot forge a silver tablespoon.

For this the main tools that you need are:

Anvil
Forging hammer (approx. weight 1800grams/4 pounds)
Planishing hammer (approx. weight 1350 grams/3 pounds)
Tongs to hold the hot metal while forging
Spoon bowl punch
Lead cake

The anvil, unlike a teist (a solid, flat, steel-cast stake), has a convex fullness with a curved top edgfe and corners. This is important so the metal doesn't become pinched and excessively thinned when hammering. These soft curves and corners are used in the shaping of the cutlery. The forging hammer has a rectangular peen end and a slightly convex round end, both with rounded edges – again to avoid unnecessary damage to the silver.

Hand forging anvil.

Both ends of the planishing hammer have a round section; one is almost flat and the other has a slightly convex shape. These hammers are larger and heavier than the ones used for hand raising.

Forging is a process of moving and reducing the section and size of a piece of metal by hammering without losing any weight or volume; there is no filing or other refining process, it is done purely by hammer work at this stage. Both the peen and planishing ends of the forging hammer are used alternately, to force, adjust and control the silver accordingly. The peen head is for stretching and shaping the metal, while the planishing end is used to straighten, flatten and planish.

MANUFACTURING TECHNIQUES, METHODS AND PROCESSES

ABOVE: **Hand forging and large planishing hammers.**

BELOW: **Hand forging direction detail.**

Planishing the spoon handle.

Our silver tablespoon starts off as a silver ingot approximately 100mm (4") long, 19mm (¾") wide by 6mm (¼") thick. Lightly scribe a line across the length at one-third distance, indicating the area for the bowl part of the spoon to be formed. (These ingots would be a special order at your bullion suppliers.)

Spoon templates

You will now need to make two base metal templates; these are exact plan views of your spoon design, one for the bowl and the other for the handle.

ABOVE AND BELOW: **Spoon templates and design.**

69

MANUFACTURING TECHNIQUES, METHODS AND PROCESSES

If you are making more than one spoon now or in the future, these templates can be re-used time and again, enabling you to make matching items in any quantity and reproducing the same design. So investing time in producing accurate templates will always pay good dividends.

Firstly anneal the ingot. Then, using your tongs to hold the silver securely, take it to the anvil. By this time the silver has cooled slightly and is ready for forging. Using the peen end of your forging hammer, start by hammering the bowl end of the spoon, working the flat surfaces and edges into a blunt point.

ABOVE AND BELOW: **Starting the spoon.**

You will soon see the bowl part taking on the shape of your design. Now start working on the handle, holding the spoon by the bowl with the spoon handle on its edge, forging the side of the handle just past the bowl. This will start to establish the handle and bowl areas. Work up the length of the handle on both the edges, followed by going over the wider top and bottom surfaces, first using the peen, then the planishing end of the forging hammer. Another anneal is now required.

ABOVE AND BELOW: **The forging process.**

Whether you are hot or cold forging it is vital that you know and establish when to stop working (hammering) the metal and re-anneal it again. Apart from the fact that it becomes harder to work if you overstress the metal, cracks can appear and this leads to real problems, especially when refining, finishing and polishing. You will soon find out that working the metal when hot requires less effort to forge; the more it work-hardens, the greater the effort required to forge, work and manipulate the metal. Your silver will become hard quite quickly and getting the balance between work-hardening it sufficiently without overworking will come with learning, experience and confidence.

Silversmithing, like many handmade crafts and trades, relies on a smith quickly learning from their own experiences, but it is also worth observing senior craftsmen at work when you have the opportunity. This combination will help you to reach good levels of competence as soon as possible, so don't miss any chance to learn and try to create as many possibilities to watch others at work.

Once you have annealed again, and always using the tongs, hold the hot silver from the end of the handle. Now, with the peen section of the forging hammer, start working the silver bowl at the handle end, spreading and moving the metal sideways from the centre of the bowl to the outside.

When changing hammering positions at any stage, just rest the blank on the centre of the anvil and pick it up again with the tongs. To help with this you can also press the hammer

MANUFACTURING TECHNIQUES, METHODS AND PROCESSES

onto the silver blank to secure and hold it on the anvil while changing grip with the tongs.

Now holding the bowl again, work and stretch the handle section. Note from the illustrations how you use the curve of the anvil to help form and keep the spoon evenly shaped and balanced. Always hammer the side, top and bottom surfaces of the handle alternately to avoid the edge of the silver folding over. To keep the spoon straight and uniform, hammer the sides, top and bottom equally. Anneal again once the silver becomes work-hardened.

Forge the handle in where it meets the bowl as soon as you can because this is where the greatest movement of the metal will occur from the original ingot, then progress along the handle away from the bowl of the spoon. Use the planishing end of the forging hammer to smooth the handle once it is stretched, also planish to straighten the handle at the same time.

If the spoon is not straight when placed on the anvil, hammer on the top of the shortest edge to stretch and correct the plan view and symmetry of your design. Work on the bowl again, thinning and spreading the metal sideways (the thinner the metal is, the quicker the surface area will stretch and spread). Regularly offer up your template shapes to see that correct progress is being made with your handle and bowl as you head towards the finished design. It is now time for another anneal.

As you progress to achieve the shape, size and accuracy of the spoon it requires less force and more fineness from your hammering techniques and smoother forging, but this stage is no less important than any other in the manufacture of your spoon.

At this stage the spoon will now be reaching three quarters of its total length. Keep checking the handle and now use the bowl template to ensure your continued stretching of the metal is working in the appropriate areas to fill out the bowl shape that is required. At this phase it is important to continue hammering both sides of the spoon bowl, now working closer towards the edge of the bowl to achieve the correct shape and balance. Forge and stretch the handle again and this will take it close to the total length required.

Strength and tension

From this point onwards we want to retain the hardness in the spoon created by the forging and hammering, so no more annealing is necessary. This will keep the spoon rigid, hard and strong; these qualities are all required through the use and life of cutlery, so these products need to be in a work-hardened condition so they are difficult to bend when finished.

Use the planishing hammer to remove all the forged hammer marks. The spoon size should now be slightly bigger than your templates which in the case of the handle will enable a line to be scribed onto the silver so you can file or linish to the correct shape. This deliberate oversize is essential because you need to be able to file the spoon on the outside section to match the shape and dimensions on your original drawing.

Now is the time to add the crank in the spoon. Using a shaped piece of hard wood or the traditional material, lead, and a collet hammer, place the spoon bowl downwards over the hollow in the stake at the point where the bowl and handle meet. With eight to ten strikes of the hammer the crank is set and you are now ready to sink the bowl.

ABOVE AND BELOW: **Cross-checking with templates.**

Spoon forged without crank.

Spoon showing the crank.

MANUFACTURING TECHNIQUES, METHODS AND PROCESSES

ABOVE AND BELOW: **Setting the crank.**

Tool and spoon in place, ready for sinking the bowl.

Pre-forming the bowl.

Sinking the bowl.

Sinking the bowl

Sinking of the bowl is achieved by hammering the spoon stake directly into the lead cake (a block of lead) that you pre-form by using the spoon bowl stake to create a well into the lead. Then use the spoon bowl stake to pre-shape the

Tools for punching.

silver blank, firstly holding the punch by hand, using it as a hammer. This will help to hold the bowl in the lead and prevent it from moving when subsequently striking the stake with a large (3kg/7lb) sledgehammer.

Note the back edge of the lead cake is shaped to receive the crank section of the spoon to avoid the handle kicking back and flattening out the crank shape. Good location of

the punch is vital at this point, so make sure the spoon bowl punch is central, level and correctly positioned in the lead. An initial strike with the sledgehammer will show if the bowl punch was in the right place. Three or four further strikes will allow the punch to shape the bowl to 90 per cent of its final shape and profile, easing the punch towards the handle to achieve the desired form and smooth transition. The bowl punch itself is highly polished, so when hammering the spoon into the lead you will see any areas that haven't been touched and formed; these areas will remain matt white and not a burnished finish (i.e. not yet touched by the bowl punch).

The reason why we use lead to form the bowl is because it allows the transferral of any irregularity in the thickness from the inside of the spoon bowl to the outside, where it is easier to work on and clean up, being a convex shape.

Still working on shaping the bowl, secure the stake in a vice and use a collet, and then a small planishing hammer, to lay the silver down, eliminating the remaining white areas by gently planishing onto the stake, continuing to work each side equally. At this stage the lead cake has become misshapen and distorted so you need to reform and start afresh.

Please note that all traces of lead must be removed from silver surfaces immediately by scraping before any further processes are conducted. This is essential because when annealing and soldering the lead will eat into the silver.

Final planishing.

Hammers used in forging.

Final sinking and finishing.

This final sinking, using five or six heavy strikes of a sledgehammer on the bowl punch and into the lead will give us the correct shape and depth of the spoon bowl. The inside of this will now be fully in contact with the stake and therefore have a semi-polished appearance because all of the punch is touching the silver bowl of the spoon. Continue to constantly check the spoon shape in all directions to ensure it is straight, even, balanced and correct according to your design.

Any twisting or unevenness is corrected now by placing the bowl back into the lead or planishing the handle as explained before. If the bowl isn't central to the handle it can be adjusted on a wooden stake or the lead cake by holding the end of the handle and tapping it onto the stake at the point where the handle meets the bowl. The spoon is now ready to be filed and/or mechanically linished.

MANUFACTURING TECHNIQUES, METHODS AND PROCESSES

Using a linishing motor to strip and refine your cutlery is best done once you have sufficient experience and knowhow. It is so quick and easy to ruin all your hard work that you have done up to this point so caution should be exercised here. The best way to file your spoon is to hold it in an engineer's vice as shown.

Forging and filing are now complete.

File the top of the bowl first, making sure it is level and accurate with the handle, checking all the views and angles by eye. Now file the handle profile, starting at the bowl end. Finally inspect the spoon for shape, dimensions, profile and symmetry, etc. If you have a green light on these criteria the spoon is ready for polishing.

Filing to final shape.

74

MANUFACTURING TECHNIQUES, METHODS AND PROCESSES

Hand forged X–Y candlesticks by Brett Payne.

ABOVE AND BELOW: **Hand forged silverware by Brett Payne.**

75

■ MANUFACTURING TECHNIQUES, METHODS AND PROCESSES

Sinking

The sophisticated processes described below ask a lot from a craftsman and should only be attempted when you are confident in your abilities and in control of your raising, planishing and general hammering techniques.

Experienced and skilled silversmiths consider these processes to be difficult and demanding but once mastered they will increase the range, type and level of work you can make and produce, whatever the technical or creative challenges that lie within. When someone has perfected these advanced hammering skills it is a sign they are a master craftsman.

An initial introduction and good way to begin learning these hammering techniques is to start with a round plate or tray, with a suggested diameter of 205mm/8in. Your starting metal blank size for sinking should always match the shape and size of your design plan view, and in this instance the finished diameter will be the same as you started with.

To begin the hammering you will need a hard wood starting stake. This is preferred because using a steel stake can result in incurring cutting marks and unnecessary thinning of the metal at this early stage of the process. As with any of our previous advice regarding good tool preparation, it is very much worth investing in making a quality stake. It will support your sinking and forming work, and the same stake can be used for many years. Lignum vitae is the hardest and best wood to use because it will stand up to hammering with the least distortion to the wood. If you cannot access lignum vitae then any good hard wood with a tight grain will be suitable.

When beginning to learn how to sink it is easier to set up your stake in a vice. The two nails (illustrated) will hold your blank in the correct position through the initial hammering stage. Start with your blank being fully annealed, pickled, rinsed and dried. When making a round plate or tray, it is wise to put a temporary piece of flat metal over the centre area of your plate with double-sided tape. This will avoid any mark or hole being made by the dividers when doing your marking out from the centre. This protective plate can be removed once the rim line is established. Without this piece of metal you will have to reverse the centre point with a small doming punch from the centre of the back when finishing the piece to eliminate the small hole left by your dividers.

Mark the centre of the tray on this piece of metal, using your dividers from the outside edge of the blank. With this newly formed centre point and again using your dividers, firmly mark out the line where the rim of the plate starts from.

Set-up for sinking.

It is important to note that this rim line will need to remain visible until you finish the tray. Now with a pencil compass, mark a circle line where the tray well will finish. When making all other shapes of trays – an oval one, for example – it is best to mark out the rim line by using an accurately made quarter template (of your plan view), using and following the vertical and horizontal dividing lines.

Quarter template for an oval tray.

Even and neat hammering as you sink the metal to begin forming the well will be key factors in helping you keep systematic control over the shape and overall symmetry of the plate. This is why a round tray is the easiest to start with because the tensions and behaviour in the metal should remain equal from your even treatment and hammering. When sinking an oval, square or irregularly shaped tray the tensions will be different, uneven and harder to correct; therefore these more complex conditions and degree of difficulty should be experienced after completing and succeeding with a circular plate or tray. Keeping control throughout every course and stage of making a tray is crucial to its success and you will find that every tray you craft will react differently.

For this method of hammering adopt the same well-

MANUFACTURING TECHNIQUES, METHODS AND PROCESSES

balanced stance as with raising. Using a collet hammer with rounded edges and a full face, hold the edge of your blank against the nails with these between you and the metal. Tilt the furthest edge of the blank up towards you at about 15°, and then begin to strike the metal just above the rim line allowing it to rest on the wooden stake.

Collet hammer.

Sinking commences for an oval tray.

As you start to rotate, turning the tray towards you, the two nails will greatly assist you in keeping the edge of the plate at the same distance from the step in the stake. It is very important that this first row of sinking is kept very neat and of even force, because it provides the foundation for all subsequent hammering courses in forming the well of the plate or tray. Once completed, continue with another row, moving closer to the centre of the tray. With each row of sinking the tray will become deeper.

Three or four rows of hammering will be enough at this first stage. The next step is to establish the top edge line of the tray and for this you will need to switch to using a steel stake and a flat collet hammer with rounded edges. A reminder: it remains critically important to be able to see the initial scribed line throughout the entire tray-making process so you hammer up to this line but definitely not over it, completing just one row. You will now have established a good edge to work from in subsequent sinking courses. By now your tray may well be uneven and rather twisted but we still move onto the next stage.

The oval tray after the first stage of sinking.

We now enter the most demanding phase of tray making: dealing with and sorting out the tensions in the base of the tray, getting and keeping it flat.

Select a tray setting hammer, the biggest, one of the heaviest and flattest hammers that you have. This will be the hardest of all hammers to master and control because when hammering the base of a tray this hammer must be very flat and level at the point of contact with the metal; it must be the centre of the hammer face that comes into contact with the tray. If you strike the metal at a slight angle you will create indents known as 'half-moons' where the edge of the hammer has caused a half-moon-shaped mark in the metal that is hard to remove on a flat surface. It is therefore very important to avoid this.

Tray setting hammer.

Your tray setting hammer is held at the top of the handle near the head end to obtain the very best control. After the

MANUFACTURING TECHNIQUES, METHODS AND PROCESSES

first two stages of making a tray, the metal and resulting tension in the centre is now trapped and has been pulled tight due to the sinking process. This stage will release these tensions and allow the centre area to become flat again. As previously stated, every tray will react in a different way; being able to correct this behaviour – and knowing when to do so – is a demanding skill that takes time to master.

To take stock of this situation, remember that the sinking stage has pulled the centre of the tray tight, so by planishing it you will be stretching and evening out these tensions. One course of setting over the tray base area should be sufficient to balance everything for this initial application. After this first course of sinking and setting you may find the outer rim has warped or twisted and this should be flattened down again before you move on to the next course of sinking. This is achieved by using a wooden punch and mallet with the tray upturned and on a steel/iron surface plate. Mallet the wooden punch onto the tray edge to help flatten it. Going round the circumference once or twice should suffice at this stage. Now anneal, pickle, rinse and dry the metal.

Hammering the patten for setting.

Return to the sinking process again but this time using a steel stake. Continue to hammer the rows until you reach the bottom of the well that you marked with the pencil line. Check your design dimensions to see if your well depth has nearly been achieved. For reaching the final well depth you need to take into account that it will go deeper still after you have followed your planishing with the cross-planishing technique, which you will need to work at and perfect.

Many trays have an applied outside edge wire, which gives additional visual depth to the piece and increases the tray's structural strength, and is therefore seen as a desirable feature to include in the design. If an edge wire is to be included, now is the time to apply it to the tray and solder it on. Once fabricated by bending, soldering, filing, fitting or casting, hold this in place with stitches (as explained later in this chapter) and split/cotter pins before and throughout the process of soldering to ensure it stays in place and no movement occurs from your setting up position. If your wire is going to be soldered in one piece we recommend using easy silver solder, because this way you will avoid taking your work up to unnecessarily high temperatures, increasing the risk and the depth of firestain in the silver.

Flattening the tray edge.

On round or oval trays you can planish the 'well' from the outside of the tray (i.e. on the reverse side that you have been working on up to this point) using a suitably shaped steel stake supporting the inside of the well profile. Work in rows around the well until this whole surface has been planished and then finally smoothed and dressed down by cross-planishing (hammering across the rows moving the tray up and down as you progress around the depth and breadth of the well).

With your final tray depth now established it is time to turn your attention to perfecting and finishing all other surface areas of the tray. You may need to use the wooden mallet on the upturned rim or reset the base again, but whatever work you carry out, do not be tempted to anneal the tray again as it needs to remain in a work-hardened condition to keep it as strong as possible when finished.

With all stages of hammering completed you are now ready to start the process of refining the planished metal surfaces in preparation for polishing. This very important phase is usually done with a pumice stone or powder, or 'water of Ayr' stone. Either or both can be used to good effect but what you use very much depends on the state of the metal and the shape and form of the tray.

It is advisable to consult a professional polisher before you embark on stoning the tray because how much time they spend on your piece and the quality of the polishing they can achieve will be dependent on the standard of your own preparation work. As with gem setting on a piece of jewellery, this can either make or break the final outcome of your

MANUFACTURING TECHNIQUES, METHODS AND PROCESSES

Ewer and dish by Christopher Lawrence and Fred Rich.

work, so it is really important to understand what the polisher needs to enhance and bring out the beauty of the tray, rather than detract from your craftsmanship. You need to do this preparation work correctly to eliminate not only the hammer marks but any change of hammer or stake marks or very slight undulations in the tray's surface.

Raising with crimping/creasing

There are two basic raising techniques for the silversmith to use. 'Crimping' (or 'creasing', as it is sometimes called) should be exercised only when the foundation of raising (as described earlier in the book) has been practised, experienced and mastered. Crimping is an alternative starting technique that can speed up the raising process without compromising the quality of your hammering. Once you have used both of these techniques you will discover which method (or combination of methods) suits you best in particular situations or working conditions.

The crimping method is achieved by fluting the silver blank prior to raising, thus eliminating the blocking process. Crimping establishes an initial angle to the base of approximately 35 degrees. Conventional raising takes longer to reach this same angle; however, it needs to be stressed that this method has to be done with great care and accuracy because there is a danger of overlapping the silver, which usually results in having to scrap the piece!

The first stage of crimping.

Silver can be crimped using either a wooden or metal hammer with a wooden or metal stake. The best and easiest combination to begin with is to use a wooden stake with a metal hammer; once you have mastered this, move onto a metal stake with a wooden hammer. This combination

MANUFACTURING TECHNIQUES, METHODS AND PROCESSES

Plan view of the first stage of crimping.

A crimping hammer (larger collet hammer).

A steel crimping stake.

will protect the silver at the initial stage and speed up the process towards the end. A crimping hammer is a large raising hammer with a slightly more rounded face to fit and complement the channel in the wooden or steel stake.

ABOVE AND BELOW: **A wooden crimping stake.**

Prepare your silver blank in the same way as if you are doing a normal raising. This now needs to be divided up into a number of equal segments, and the number required depends on the diameter of your blank. As a general rule, the larger the diameter, the more sections you will need.

- Up to 200mm/8" diameter: make eight divisions.
- Between 230mm/9" and 300mm/12" diameter: make twelve divisions.
- Between 300mm/12" and 400mm/16" diameter: make sixteen divisions.
- Above 400mm/16": for every additional 100mm/4" add four more divisions.

Mark these sections using a soft pencil. Make a master template (made from plastic, metal or wood); this can be used in other silversmithing projects. The diagram below shows a 200mm/8" circle blank marked out into twelve divisions with the order in which they are to be hammered. This will ensure an even stressing of the metal when fully crimped. Mark your design base size from the centre of the blank. This is where your crimping needs to end.

To start crimping, hold the blank in one hand above the crimping stake. Line up a pencil mark on the edge of the

MANUFACTURING TECHNIQUES, METHODS AND PROCESSES

The master template.

The blank is marked out and hammering has begun.

The first stage of crimping.

blank with the centre of the groove. Now start to hammer the silver down into the stake, working from the edge towards the centre but only moving 25mm/1". At this first stage only hammer the metal down about 12mm/½" into the stake. Moving to the opposite segment, repeat this action and then work round all the numbers (in ascending order), doing opposite crimping in pairs until the whole blank has been initially crimped. Repeat this process but now working towards the centre of your blank (up to approximately 6mm/¼" away from your base line). Use the same order but this time hammer to the bottom of the crimping stake. You should now have achieved an angle of 35° from your base of the bowl.

Now apply Argotect, anneal, pickle, rinse and dry the silver.

Use a moderate hammering force when crimping because the metal is soft and it should move easily using this method. As in all hammering techniques, with crimping you need to place your hammer blows carefully, making sure they land in the centre of the crimping stake groove.

Because of the undulating shape and the metal's inherent characteristics, the first course of raising is critical, and the overall success of this process is very much dependent on using a good, precise technique, taking great care as you caress these areas down onto the stake.

You will now be using a stake similar to that used when doing a normal raising without crimping. Your hammering will focus mainly on the crimps, with the areas between needing fewer hammer blows, particularly as you work towards the top outside edge.

The crimps need to be captured then hammered out in the following fashion. The first hammer strike holds the crimp on the right. The second one holds the crimp on the left; the next two or three hammer blows are directed in the centre. Every crimp must be dealt with in this way or the silver will not compress, contract and raise properly. Continue raising the silver. You will need to increase the force of your hammer blows progressively as you get closer to the top. When you are about 25mm/1" away from the top edge, tilt the piece towards you, increasing the angle to about 35°. This will prevent the top of your raising from flaring out, keeping it at least straight or even tucking it in. As with raising without crimping, care is needed upon reaching the final row of hammering at the top so you don't squeeze and thin the silver unnecessarily. A wooden mallet can be used for this final row right up to the top edge.

This method of raising needs more care and attention to

Hammering out the crimps.

Repairs to the side cracking.

look for cracks and overlapping especially at the top of the piece. If cracking is detected anywhere it must be dealt with before commencing the next course of raising. Only one or two courses of crimping will be necessary before the ordinary raising process continues.

Cracking during raising

Cracks can be caused by overheating while annealing, trying to raise too quickly, hammering too hard, or even by a fault in the silver. Remember all guide markings on the surface should be done using a pencil, as any applied with a scriber or dividers can develop into cracks as well. After detecting a crack – even a hairline one – during any method of raising, you need to repair it in the following way.

If the cracking is on the edge of the piece, using a piercing saw blade slightly thicker than the split, pierce to the bottom of the crack and go on for 1.5mm further. This will create a clean and neat surface for accepting solder. Now clean the inside and outside surfaces around the crack with emery paper, Scotch Brite or a smooth file. Apply flux and solder the full length using hard silver solder, trying to ensure that the solder is proud of the metal thickness. After soldering, let the piece cool before pickling, rinsing and then drying. Carefully remove any excess solder, ensuring that you don't thin any of the metal gauge. Now the piece is ready for the next course of raising.

Where a crack has appeared on the side of the piece, if it doesn't go right through the gauge then clean it with a sharp scriber or spitstick and solder. If you can see the crack on the inside too then drill a small hole slightly above the crack the same size as the piercing saw blade you will be using. Now pierce and solder as described before. Should either of these cracks be too wide to solder (wider than 0.5mm/$^{1}/_{64}$") then you will need to gently hammer them together to close the gap down before soldering. This is best done on the same raising stake, using a planishing hammer.

Peening

Peening is another specific hammering process and an alternative method to that of raising; it is often used to form bowls that require a thick edge. As with sinking a tray, the blank size you start with is the same as your design plan view. It is the thinning of the metal from the centre towards the outside edge of the bowl that creates the movement and conditions of forming in this manner. So when you finish the peening, the gauge on the top edge of your bowl remains virtually

Repairs to the side edge.

unchanged from its original thickness. This is because peening stretches the centre of the blank outwards and the metal is therefore constantly being moved to the outer area, forming a shallow bowl. The more courses of peening you complete, the deeper the profile of the bowl will become.

Because this process always stretches and thins the metal in the centre area of the bowl there is a limit to the number of times a blank can be peened. As a general rule, the height of a bowl should not be greater than a third of its diameter. For example, a circular blank of 150mm/6" diameter with a thickness of 1.6mm/¹⁄₁₆" will form a bowl of the same diameter, with a height of around 50mm/2". The centre thickness of this bowl will have been thinned to about 0.8mm/¹⁄₃₂".

Peening development stages.

Starting with a fully annealed blank, mark the centre point on each side (you will need the second reference point at the concluding stage of hammering) and using a pencil compass draw circles from the centre, 12mm/½" apart right out to the outside edge. Unlike the blocking process, peening begins from the centre, working outwards leaving the last 12mm/½" unhammered. Using a full faced planishing or blocking hammer, the metal is directly squeezed between the hammer and a flat steel stake. Working in circles, overlap each hammer blow and then each circle with each other, continuing to the outer edge, less the 12mm/½" already mentioned. On the same principle as sinking, it is crucial to keep your hammering neat, systematic and of equal force to produce a uniform, accurate and symmetrical shape.

A teist (a solid, flat, steel-cast stake) is best used for this process. It must be clean and free from any small pieces of metal that could be hammered into the silver. After the first course of peening you will see gentle dishing occurring.

Anneal, pickle, wash and dry your metal after each course and repeat until you have achieved the shape and depth you require. After checking the form against your design and supporting template, the last peening course is completed with half the hammer strength to ensure there are no excessive marks on the inside of the bowl before going onto the planishing stage. You can now draw your guide lines/circles on the outside of the bowl and planish to finish the process.

ABOVE AND BELOW: **Alternating the peening process.**

When peening a blank that is oval, square, rectangular or of an irregular shape, it is best to alternate the direction of your hammering courses from clockwise to anticlockwise to avoid twisting or spiralling your bowl as you progress through the hammering stages.

Scoring and folding by hand

Scoring and folding are useful, long-practised techniques that are still used today and remain fundamental in a contemporary

■ MANUFACTURING TECHNIQUES, METHODS AND PROCESSES

silver workshop. There are many instances in silversmithing where these skills can be used across a variety of components and articles, for instance boxes, bases, handles, vessels, etc. It is also possible to score curved lines. The small square box we have featured guides you through these hand-crafted methods. The machine processes of milling and engine turning are accurate alternative techniques.

Marking out

The first and most important stage to successful, accurate and crisp scoring is to carefully mark out clean and definite single lines on the silver. These must be well measured, neat and very precise because if you are a fraction of a millimetre out in the marking process this could make your overall form inaccurate and out of true. This aspect is crucial and it is the bedrock of successful scoring so you must invest sufficient time to ensure that everything is as it should be before moving on to each subsequent stage.

Marking out the score lines.

Most new silver sheet is supplied with a protective plastic backing. This needs to be removed on the side that is to be marked out but kept on the other side to prevent excessive scratching when working through the stages of scoring.

Whenever possible use dividers to mark out your score lines with reference arcs. Using a ruler and scriber can lead to your guide lines becoming inaccurate, sometimes causing multiple lines, and accumulative errors may be incurred. When starting a square box, make two edges of the silver sheet flat, square, and at right angles to each other. You can now use these two sides as your square edges and as starting points for mapping and marking out your guide arcs.

Scribing in the score lines.

Once you have marked out all your small arcs with dividers, now use a sharp scriber to very carefully score the lines. You will find it easier to place the scriber onto the divider arc then position your steel ruler up to the scriber using this as a fixed point, before moving the other end of the ruler to the next divider mark, and scoring your line. Follow this with a blunt scriber using the same method but achieving a much deeper line; this will give you a more secure and definite groove to score into. Again, it is very important when you start scoring to keep the cutting tool within the groove you have provided.

Scoring

It is essential that you use a sharp scoring tool to achieve the correct finished angle, with consistent depth and accuracy. These are often made from old files although you can

MANUFACTURING TECHNIQUES, METHODS AND PROCESSES

Handmade scoring tools.

Silver secured and scoring in progress.

Checking the cutting angles.

of the line and carefully draw the scoring tool back towards you, running off the edge of the sheet if appropriate. Repeat this five or six times until the scored groove is deep enough and well established.

Achieving depth and consistency.

purchase a scoring tool from jewellery and silversmiths tool suppliers. If your box is to be square with upright sides then all your folds will be 90°. Your scoring tool will also have a 90° leading edge; this can be checked using your steel square.

Place your silver onto a wooden board that is held firmly in a vice, often by another piece of wood screwed underneath the board. Secure the silver during the scoring process using small flat-head nails hammered into the wood, usually two nails on each of three sides. Keeping the fourth side open allows you to check and turn the silver when necessary.

Stand with the open end furthest away from you at the top of the board and rest your scoring tool in your scribed groove. Now carefully push the tool away from you and up along the line towards the top of the sheet. This will establish the bottom of the groove to be the same section as the scoring tool, making it much less likely that you will slip when you start scoring. Repeat this process a few times, then place the scoring tool, dipped in a light machine cutting oil, in the top

85

MANUFACTURING TECHNIQUES, METHODS AND PROCESSES

Score each of the lines to the same depth before carefully checking with dividers that they are all still accurate from the square edges. Any inaccuracy can be adjusted using a small square needle file to move the line to where it should be. Continue scoring, making sure each line is the same depth and V-section. The sheet can be turned round periodically because it is good practice to start and finish scoring from different ends, to retain accuracy and consistency of depth and this avoids deeper lines from one starting point on a single line.

Making fine adjustments.

Sometimes it isn't possible to draw across an intersecting score line and you will have to stop and re-start scoring before and after these junctions. All your 90° scored grooves can now be trued up and finalized with the square file.

Checking and final preparation

Peel back a corner of the plastic backing on the underneath of your sheet to reveal the indent lines created from the scoring process. It is the depth of these lines that will determine whether the groove is deep enough to start folding. It is wise to practise this difficult technique on some small sample pieces of sheet, to gain experience in how deep, accurate and consistent the lines need to be before you fold the sides up. As a guide, you should be looking to score to a depth of 0.8mm (1/32″) if the sheet is 1mm thick. You usually get one chance only when folding the metal, and you will soon find that if you decide to bend a section back down to flat to do some more filing on the groove it is likely to break off when you bend it back up again; practice makes perfect in this instance, and this is an unforgiving technique if you get it wrong.

Revealing indent lines.

Piercing

With all the lines accurate and at the correct depth, pierce a line 3mm/1/8″ on the outside of your scored line in the waste corner, carefully reaching the bottom of the groove in the horizontal line. With the silver on a surface plate, carefully lift

Piercing out a waste corner.

MANUFACTURING TECHNIQUES, METHODS AND PROCESSES

the waste corner up. This is a good indication of how well you have scored this line because the corner should fold up to 90°.

If it doesn't or it resists folding then more scoring is required before folding the actual side up. This waste corner can now be folded down and up until it breaks off. Repeat this on the other three corners; your sheet should now look like the example in the photograph.

Folding

Clean all traces of cutting fluid away and wipe the groove with Scotch Brite to make sure it is clean in preparation for soldering. Continue working on the surface plate, firmly hold the sheet trying to avoid touching the cleaned edges and fold up as shown. For larger work, it is better to do this by using a flat piece of wood or steel to keep the sides true. Finally you have a scored, folded and formed box.

ABOVE AND BELOW: **Lift the corner up and down to break off and remove.**

ABOVE AND BELOW: **Folding commences.**

Waste corners removed.

Folding the opposite side.

87

MANUFACTURING TECHNIQUES, METHODS AND PROCESSES

Completing the folding.

Bind the box using small steel corners to prevent the binding wire cutting in when heating. Your box is now ready for soldering.

The box has been folded and bound, and is ready for soldering.

Seaming

Seaming is an important technique in the range of manufacturing processes that are available to the silversmith. This popular production-based technique is often used to save time and money and is therefore an economic necessity in certain business situations. It is particularly relevant if your commissions do not cover the cost of labour-intensive hand raising, and also when spinning is not a possible option.

Seaming silver sheet is a relatively quick method of making forms, particularly cylinders and cones, although most forms can be seamed. It is a basic process in which sheet is formed into a shape and the main edges are soldered together to complete and enclose the form.

The development of a cone, using the radial element method

Start by drawing the cone in side view, followed by a top plan view. Now divide this into twelve segments; this will give you greater accuracy when developing the cone. These twelve lines are now projected up onto the side elevation. In this same image and using a pencil compass obtain the true length of the cone. Next draw a circle, and then mark these divisions at the circumference of the circle. This is then projected twelve times onto the circle drawn earlier, to match the twelve segments on the plan view. You now have your true development of the cone. Cut this out, and form to the cone shape as illustrated.

From your design it is good practice to make a developmental template, so that you can have an accurate flat layout of your design for marking out onto the metal sheet. Geometrical forms can be drawn using a mathematical formula; however, free-form, more sculptural designs may require a simple 3D model to be made in modelling clay, wax, wood, styrofoam, paper, aluminium, etc. From this, paper can be wrapped around the model and cut to size, giving you a flattened outline of your design, for you to form your 3D piece from silver sheet.

Apply the paper template to your silver sheet using double-sided tape or spray glue. Alternatively, draw round the template with a scriber. Depending on your template use a mechanical bandsaw, piercing saw or a combination of the two, to cut out the shape. When you have formed the sheet and completed the shaping process try to ensure the two edges are as close to each other as possible.

There are different methods to achieve this, for instance, by malleting the ends to bring them tight against each other. To get these tighter still, use a pencil to mark where the points are touching, pull the joint open slightly wider than a file width to be able to dress these high points down, being careful to only file the marked areas. Close the joint up again to see the progress and repeat this until the edges are tight along the entire length of the joint. This is very important because inconsistency will result in stronger and weaker parts of a soldered joint, which can then lead to a variety of problems, such as pin holes in the solder line, splitting when hammering over the soldered joint, and irregular surfaces when finishing and polishing.

Another possible method when the type of joint allows (i.e. a flat line as in the case of a cylinder or cone) is to saw carefully along the joint. This can be done with a bandsaw,

MANUFACTURING TECHNIQUES, METHODS AND PROCESSES

1 Cone development calculations.

2

3

4

5 Development layout.

6 Forming in progress.

7 Ready for binding.

8 Ready for soldering.

89

hacksaw, junior hacksaw or piercing saw, and often with this method there is no need to file the joint. In preparing a joint for soldering, make sure you keep an even thickness throughout its length. The two edges must remain a tight fit along the entire distance of the seam. When this has been achieved, the joint can be soldered (please refer to the section below on soldering).

Once soldered, pickled and dried, check your joint is fully soldered on the inside and outside. Then make sure the two ends are flat together. If the metal has moved during soldering and there is a small step in part of the joint (or along the entire joint), this will have to be rectified before continuing. Carefully file off any excess solder without filing the silver itself. If the step covers more than half the gauge you can lead it down. This process will protect the original thickness and re-establish a flat seam.

Using a piece of lead sheet 50mm × 25mm (2″ × 1″) and 2mm/¹⁄₁₆″ thick, holding it at the long end with the other covering the uneven joint. Now using your planishing hammer, carefully hammer the joint with the lead sandwiched between the silver and hammer. This will even out the seam and leave a small step which can be filed off. Remove any traces of lead.

With your joint now flat and even, carefully remove any excess solder from the inside and outside of your piece, leaving a clean seam.

Soldering

In general, for most heating and soldering requirements in silversmithing workshops, the combination of natural gas and compressed air is the most satisfactory and efficient, enabling fine adjustments of flame size and temperature and giving good overall control. Alternatively, bottled pressurized propane gas can be used if natural gas is not available, and this is a good secondary resource.

Enamelling silver solder

This very high temperature solder is primarily used when work is to receive vitreous enamel because of the excessive demands on the solder through multiple firings when enamelling. This solder is also very useful as first stage soldering when a piece requires multiple soldered joints. Wires are often soldered with enamelling solder; this gives an extra margin of safety when using lower grade solders, as the enamelling joints will not melt.

Hard silver solder

This is used in two- or three-stage soldering applications where you intend to use easy or extra easy solder as your second or third application.

Medium silver solder

This can be used in making pieces with multiple joints, but you will find that most silversmiths will not use or recommend this solder, as it can be difficult and problematic to use and apply; hard solder is usually the preferred option.

Easy silver solder

This is the most popular and commonly used solder, and if your work requires only one soldering then this is the best solder to use. It gives strong but also ductile joints, and tends to flow beautifully when you provide the correct conditions for clean and neat soldering. The main advantage of this grade of solder is that you are not subjecting the silver to the higher temperatures necessary for enamelling, or hard and medium solders.

> **SILVER SOLDER OF HALLMARKING QUALITY**
>
> The following solders are available from most bullion suppliers and are used when joining silver and base metals such as gilding metal and copper:
>
> Enamelling: melting range 730–800°C
> Hard: melting range 745–778°C
> Medium: melting range 720–765°C
> Easy: melting range 705–723°C
> Extra easy: melting range 667–709°C

Extra easy silver solder

This is used when multiple soldering is required, or even just for two joints where the first application is done in easy solder.

Note: an "Easy-flo" solder is also available and this melts below the extra easy grade at 630–660°C. It is seen as a 'get you out of trouble' solder. However, we must stress that this grade solder would not pass the hallmarking standards.

Fluxes

The purpose of fluxes is to keep all relevant areas clean and free of impurities, and to be resistant to oxidation on metal surfaces for soldering in order to create a clean, neat and strong weld. When soldering with easy or extra easy silver solder, 'Easy-flo' flux can be used. This powder-based product is mixed with water into a smooth paste, and its holding and cleaning properties work extremely well on these low melting point solders.

Borax, the mineral salt sodium pyroborate, is best used when soldering with enamelling, hard and medium silver solder. This is available in cone form, and is ground and mixed with water into a smooth paste in a ceramic dish. The joint areas to be soldered should be free from any oil, grease or dirt and preferably cleaned/prepared with a file or scraper. If using emery paper or Scotch Brite cloth, care should be taken to remove any residue when using these materials. A clean joint is vital in preparation for successful soldering and this should never be compromised.

The flux should be applied to the joint areas and solder before heating commences. If the duration of heating time is prolonged or the size of the joint is large, further flux applications can be made during the process. It may be necessary to warm the piece gently to ensure you keep the flux paste covering the whole of the joint area. The torch should at first be held some distance away from the work so that the flame heats the work generally and allows the flux to settle, rather than bubbling up too quickly and possibly flaking off the joint. The torch should always be directed to the larger components to be joined, otherwise the smaller sections heat up too quickly; solder will always move towards the hottest point of temperature. Even heat across both areas of the joint will result in a successful and unified weld. During heating the flux will bubble and melt into a clear liquid, and with the correct and even temperature, solder will flow into the joining line, spot or joint.

Soldering techniques

Various techniques can be used when soldering, but the two main methods that silversmiths use are:

1. Pre-placement: small pieces of solder called 'pallions' are placed on the joint seam prior to heating with the flux. The joint area is then carefully heated up to temperature until the solder flows into the joint. Pre-placement can also be applied after gentle heating once the flux has settled down. The advantage of this is that once placed the solder is less likely to move, whereas if you place the solder when the silver is cold, upon heating, the flux can be displaced from its intended position (or even ping off the area if heated too quickly). This method can also be used with longer pieces of strip solder called 'panels', where stick feeding would be difficult. The flow of solder can be assisted by stroking it along the seam using a soldering probe made of steel.
2. Stick feeding: the fluxed joint is heated to temperature and the tip of the solder strip (also pre-fluxed) is fed into the joint at the correct temperature. The solder will melt on contact with the joint when applied.

For both techniques it is paramount that when heating for soldering the highest temperatures are always focused on and around the joint to be soldered, because solder will always flow to the hottest position. It is also important to keep the length of time at soldering temperature to a minimum, because prolonged or excessive heating at this level can burn the solder, which reduces its weld strength and the joint can become baked and brittle.

When you start heating for soldering in most cases you can gently warm the whole piece using a bushy soft flame, and you will protect the flux by not burning it at the initial stage before it settles and turns to a clear liquid. This careful approach will also help to keep the joints or additional pieces to be soldered in the original position you placed them when applying the flux paste. It is vital to keep joints tight together before and during soldering for successful joining.

As we have seen, there are various ways of achieving successful soldering and usually each individual situation will determine the method you should employ.

Binding

This is the most widespread method of temporarily holding pieces, sections and components together for soldering, and we use soft iron round binding wire (0.5mm diameter for small articles and 1mm diameter for larger pieces). When wrapping pieces with binding wire, and especially anything with square corners, take particular care because unnecessary marks and damage can be incurred when soldering if the wire is not correctly applied and positioned. Roughly determine the length of wire needed to wrap around the outside of your article, adding a few centimetres for twisting the wire to tighten and secure the position for soldering.

The soldering process.

Binding a cylinder

Bend the wire in half and twist the middle (rounded end) together to form a small loop. Now with the loop opposite the joint, wrap the wire around the circumference joining the two ends with a few twists. Use parallel pliers to tighten the first loop, pulling the wire away from the article before twisting it. This method helps to get the wire tighter and protects the binding wire from breaking. Finally tighten the two ends until the joint is close together. On longer cylinders, two or three wires may be needed to hold the whole length of the joint evenly closed.

Up to soldering temperature.

Binding a piece with corners

Providing a twisted loop of binding wire at each corner is essential, otherwise the wire will cut into the corner of the silver, especially so at soldering temperatures. Alternatively, temporary small steel corners may be placed between the silver and the wire to prevent any cutting in.

Spinning

This age-old process of forming three-dimensional components with a whole array of shapes, sizes, complexities and fittings, remains one of the most popular and cost-effective ways to produce silver designs. It competes favourably against any other method of manufacture in terms of the time taken, the volume that can be produced, and the accuracy of the units each and every time. Rather like the art of traditional raising, the techniques involved have remained unchanged over the centuries and there has never been a more impor-

Wire bound with steel corners.

MANUFACTURING TECHNIQUES, METHODS AND PROCESSES

tant time for this fast-forming and exacting technique to play its critical role in helping silversmiths to compete globally, particularly with the spiralling costs in precious metals.

In our view, there are too few spinners practising this specialist technique, although the pure economics of manufacture and production will mean that designers, craftsmen and managers will constantly consider using spinning within the production of their designs. Consequently, we feel it is very important to explore the technique of spinning here. To this end we organized a spinning workshop with John Need, a master spinner with more than fifty years' experience, and have captured John's mastery in the accompanying images that take you through the various stages of spinning. First of all, a simple beaker is created; then a more complicated vessel, which requires a split chuck to enable its concave shapes to be spun and formed.

The technique of spinning can be used to create an extensive range of shapes and forms, from very small profiles suitable for jewellery, up to incredibly large component parts – trophy bodies, for instance. The next short section of the book will help to show you its considerable potential and how you might use it in your work.

A hand spinning lathe is quite different from any conventional engineer's lathe. As you can see, it is extremely basic: there are no front handles or dials to operate the machine in the traditional way. All the work is done by using hand tools, the lathe's rotating force, and the tool rest to lever and form spinnings over chucks, which are made from various materials (wood, nylon, steel, brass, aluminium, etc.). As you will see in the accompanying images, the chucks play a crucial role in the spinning process, in which metal is coaxed and nurtured towards the intended form.

These chucks are held in place by a central steel thread, the size of which is commonly 25mm/1"; smaller chucks have a 19mm/¾" thread. As mentioned, spinning chucks can be made from a variety of materials; historically lignum vitae, a very dense, heavy and tightly grained wood was the favoured material, but it is expensive and harder to obtain today so many spinners are using nylon as an alternative. Other hard woods (such as oak, mahogany and beech) can be satisfactory substitutes for lignum vitae, but chuck marks from the grain in the wood may be pressed into the inside of the spinning. Aluminium, brass and steel are preferable for larger quantities of spinnings because they last longer and retain the original profile of the chuck, irrespective of the number of times they are used – a clear advantage over wooden chucks – but of course they take longer to produce and cost more as a result.

If you are doing a one-off spinning you can keep changing your drafting chucks by turning them down on the lathe as you progress through the spinning stages, using the same piece of nylon or wood throughout. This obviously shortens the time taken to produce a single spinning form, whatever the requirement is. In most cases, however, spinners will have a good selection of different sizes and shapes of drafting chucks to cater for the wide variety of work they will be asked to create.

Your stance, hand positioning and application are vital to successful spinning, and also to protect your back from injury. As in the case of polishing, the positioning and point of contact with a tool to the rapidly rotating metal is of critical importance, not just for creating the right conditions for successful spinning but also from a safety perspective.

The metal blank is held in place between the chuck and back centre by the 'tailstock', which is fixed to the bed of the lathe. This pressure is constantly checked throughout the spinning process to make sure the blank doesn't come loose throughout the spinning operation. Photograph 3 in the following sequence shows the blank being trued by a flat spinning tool. It is at this point only where the pressure is released slightly to get the blank running true and central on the lathe, after which the pressure is then re-applied. After every annealing you must apply a lubricant on the blank, to prevent the spinning tool from biting in or sticking to the metal. Use tallow, a natural compound, or a thick oil for this purpose and do not skip on this application throughout any of the spinning stages.

The first stage of spinning is to establish the corner close to the back centre. This will hold the metal onto the chuck more securely. Note the hand positioning on the spinning tool and the tool rest; this changes when more pressure is needed and applied. During the drafting stages (stages 2, 3, 4 and 5), the metal isn't pressed hard down against a chuck – these chucks or mandrels are primarily used to hold and support the metal. As with hand raising it is important to anneal the metal after every spinning course to eliminate the tension in the metal. You can see from the different 'stage complete' photographs just how much the metal moves between each course. For the fifth drafting stage, two spinning courses are necessary, because this amount of movement will ask a lot from the metal and the edge can become wrinkled or even split if you try to spin the metal in too far at any one time.

As previously mentioned, each new course begins by lubricating the metal and establishing the base corner. Now (stage five) for the first time, the metal is 'laid down' onto the

MANUFACTURING TECHNIQUES, METHODS AND PROCESSES

wooden chuck. After another anneal, pickle, wash, dry and lubrication it is ready for the final chuck, which in this instance is made out of brass (stage 6).

Spinning with and onto metal chucks needs as much care as hammering on metal stakes, because the silver can be very easily stretched and thinned if excessive pressure is applied with the tools and your own force. The final laying down is now done, but the top edge of the spinning away from the chuck is left; this is then trimmed using a hand-held lathe cutting tool to achieve a neat, clean and true top edge. It is done this way to prevent the trimming tool cutting into and damaging the finishing chuck.

The final stage of the spinning is to planish the metal. This will take the metal down onto the chuck and achieve a very smooth surface and finish. A well-finished spinning should allow you to take it straight from the spinning lathe into the refining stage of polishing without any additional treatment (file, emery, pumice, water of Ayr stone, etc.) and this has a clear advantage over any other manufacturing method – yet another plus point for spinning.

In most cases spinnings are left in a work-hardened condition; this is advantageous to the silversmith because the piece remains stronger, will hold its shape better, and resist damage such as bruising or denting. However, if any additional shaping is required after a spinning has been completed, the silversmith will need to anneal it before any work commences. For example, if there are any base wires, handles, components or other spinnings etc. to be soldered together, any residual lubricant from the spinning process must be thoroughly removed before soldering. Do this in hot soapy water to ensure that you have the right conditions for successful soldering.

Basic spinning: beaker

1. The spinning lathe.

2. The first draft chuck (wood).

3. Truing the metal blank.

4. The first stage of spinning.

MANUFACTURING TECHNIQUES, METHODS AND PROCESSES

5. Laying down.

6. The first stage is complete.

7. The second draft chuck (wood).

8. The second stage of spinning.

9. Laying down.

10. The second stage of spinning is complete.

11. The third draft chuck (wood).

12. Stage three begins.

95

■ MANUFACTURING TECHNIQUES, METHODS AND PROCESSES

13. The mid-point of stage three.

14. Laying down.

15. Stage three is complete.

16. The fourth draft chuck (wood).

17. Stage four begins.

18. Stage four is complete.

19. Annealing.

20. Stage five begins.

96

MANUFACTURING TECHNIQUES, METHODS AND PROCESSES

21. Laying down.

22. Stage five is complete.

23. The finishing chuck (brass).

24. Applying tallow.

25. Stage six begins.

26. Laying down.

27. Trimming back the edge.

28. Planishing/burnishing.

97

29. The spinning process is complete.

30. The finished articles.

Split chuck spinning

As well as producing simple shapes, more complex forms can be spun, but this calls for a more sophisticated and complicated chuck made up of small sections that can be removed piece by piece once the spinning is finished (rather like the segments of an orange inside your spinning, set on a central core). A conventional solid chuck would be impossible to remove from a spinning where the metal has been taken past the widest part of the chuck. In fact if the chuck was wooden you would have to burn this out, but of course you would lose the chuck for future repeat spinnings.

This method relies on absolute accuracy in the split chuck and getting the size, length and diameter of your spinning just right for sliding onto the split chuck (i.e. your metal must be spun into the concave shape and form of the split chuck). The images in this section show the profile, where it would be obvious that the vessel will not come off the chuck; the sequence of images demonstrates how this can be done by deploying the split chuck.

Because of the additional investment involved in producing split chucks, this method can only be really cost effective on volume orders. The return, however, is being able to produce complex shapes in quantity; this impressive method of production will always challenge the technique of raising by hand, particularly if a series of the same units is required.

You will see from this sequence of images for advanced spinning that all the stages leading up to and including the planishing of the metal onto the chuck follow the same pattern and procedures as described for basic spinning (as previously described). Therefore we have focused this commentary at the point of using the split chuck.

One very important requirement from the outset is to ensure that you have the correct height from your spinning before starting with the split chuck. If this is not the case we advise you to use the existing chuck again and planish more to stretch your metal up to the height that is needed, to avoid doing any of this on the split chuck assembly.

You need to assemble the split chuck on the lathe as indicated in the photographs. Then place the spinning over the end of the chuck. There should be a tight sliding fit to the chuck, as this helps to keep the chuck sections in place as you are preparing for spinning on it.

The spinning is then pushed further on the chuck by using the tailstock and back centre until the base of the spinning and the base of the split chuck touch. As with all spinning stages the first area to establish is the base, although the final metal draft chuck should match the shape of the split chuck up to the height/point where the spinning starts to go concave, so very little work should be necessary on this part. The spinning is now carefully dressed down into the split chuck section. After a final planish the top edge is carefully trimmed, taking care not to touch the split chuck and cause any possible damage (as discussed in the description of basic spinning).

When the lathe is stationary, slide the split chuck from its centre core and remove the 'key' section. Then it will be possible to remove all the other sections one at a time. This spinning is now complete.

MANUFACTURING TECHNIQUES, METHODS AND PROCESSES

1. John Need, master spinner.

2. Spinning on the draft chuck.

3. Working the centre section.

4. The final stage of drafting.

5. A nylon chuck is used for the next stage.

6. The beaker ready for spinning.

7. Spinning starts on the nylon chuck.

8. Laying down the metal.

■ MANUFACTURING TECHNIQUES, METHODS AND PROCESSES

9. The end of the first phase on the nylon chuck.

10. The last draft on the nylon chuck.

11. Working the top section down.

12. Spinning on the nylon chuck is complete.

13. The final draft chuck is aluminium.

14. Establishing the base corner.

15. The final laying down onto the chuck.

16. Planishing/burnishing.

MANUFACTURING TECHNIQUES, METHODS AND PROCESSES

17. Stretching the beaker height.

18. Starting to assemble the split chuck.

19. Bringing on segments.

20. Components coming together.

21. Placing the last segment.

22. The piece is pushed on and positioned.

23. Moving the metal inwards.

24. Spinning in and down onto the chuck.

■ MANUFACTURING TECHNIQUES, METHODS AND PROCESSES

25. The top edge is laid down.

26. Planishing/burnishing to finish.

27. Trimming the top edge.

28. Removing the 'key' section.

29. Chucks and other components.

30. The last stages of spinning.

31. Tools of the trade.

MANUFACTURING TECHNIQUES, METHODS AND PROCESSES

32. A plug chuck.

33. The plug chuck is separated.

Salt cellar, spun components, by Padgham & Putland.

Candlestick – all components spun, by Padgham & Putland.

Plug chucks are used where the design is open ended and the chuck divides at the narrowest point as seen in the images above. This is an economic method of tool making and spinning where the design permits.

Spinning: the finished product

This salt cellar by Padgham & Putland perfectly illustrates how the craft of spinning can successfully create/replicate a production-led design. It was created entirely from spun components, which were brought together and finished with a minimum of time spent in crafting by hand. Equally apparent, the spinnings can be reproduced in volume at competitive prices – no other method of silversmithing production can match this.

■ MANUFACTURING TECHNIQUES, METHODS AND PROCESSES

Model-making and modelling

Another fabulous but also highly specialized aspect of silversmithing is to replicate items in silver with precision, control, fine execution and good interpretation. There are usually a number of techniques and processes involved with these detailed and complex 3D pieces. Some craftsmen focus in this specialist area and are able to produce state-of-the-art representations through their skills and experience. Padgham & Putland deliver high-class models within their business; the images shown in this section represent their portfolio.

Models in silver can be created and produced in a variety of different ways.

Hand fabrication methods

The model of Concorde shown has been crafted using some of the traditional hand-making skills of the silversmith, which were appropriate for this type of model and construction requirement. The fuselage has been forged from solid silver bar and the plane's wings were cut and shaped from sheet. Once the fuselage and wings had been refined and perfected before and after soldering them together, details such as the stabilizer and engine units were applied and soldered on. The fine applied detail is hand-engraved and the logos have been cold enamelled.

The silver model of the Pantheon in Rome is a good example of bringing a variety of processes and techniques together in a single piece of work. This particular construction demonstrates a successful marriage between hand production and technological processes. The columns, wire detail and lettering at the front of the building are all rapid prototyped and cast. The tiled roof has been handmade in wax and cast through the 'lost wax' process. The main domed roof was hand spun on a lathe, and the round, wall section under the roof was hand fabricated from sheet into a cylindrical shape. The rear box section of the Pantheon and base were scored, folded and soldered. We believe this example shows and supports the need for craftsmen to acquire skills and capabilities

Silver model of Concorde by Padgham and Putland.

MANUFACTURING TECHNIQUES, METHODS AND PROCESSES

Silver model of the Pantheon in Rome by Padgham and Putland (and detail).

105

MANUFACTURING TECHNIQUES, METHODS AND PROCESSES

across various techniques and processes, both old and new, and also endorses the need to move with the times and be competitive in an ever-changing environment of workshop processes and techniques.

Stamping

Another technique not covered so far is stamping detail and form into metal through the use of steel dies. Patterns, lines and details can be accurately cut into steel which is then hardened and used in a fly press, either hand or hydraulic, to impress the detail onto metal sheet. This technique is well suited to repeating precision detail, particularly in low profile designs.

Fine examples of this technique are the vertical walls on the silver gilt models of Mecca and Medina, where fine detail has been stamped. This process starts from accurate drawings done by hand or on computer, the details of which are translated via a pantograph/CNC machine onto a steel die. Once hardened, thick silver sheet rectangles of 2.5mm thick are struck by the die in a drop or hydraulic press.

Silver gilt model of Mecca by Padgham and Putland.

Detail of model.

Silver gilt model of Medina by Padgham and Putland.

Detail of model.

MANUFACTURING TECHNIQUES, METHODS AND PROCESSES

Each of these two models required five or six dies to cover the various detail requirements. Once stamped the different sections were then fitted and soldered together to form the outer walls and main structure. A square wire fitted and soldered on the inside and near the top of these walls allowed the roof to be held into position, and the roof details were used as anchor points through the building and down to the base. These also locate and lock the base sheet into position.

The towers and minarets were rapid prototyped, lost wax cast, hand and machine finished, and finally bolted into position (also down through to the base). This somewhat simplistic description of the methods employed gives an insight into how to go about fabricating this type of model, and how to achieve the clean, crisp and professional outcome that is clearly demonstrated here.

Rapid Prototyping (RP)

The fine detail in the silver model of the Galleria Colonna was achieved using one type of rapid prototyping technology (CAD/CAM). Each highly detailed and intricate part has been created and generated on a computer programme, then machine cut in wax using a small milling machine (such as a Roland CNC model), sometimes with cutters as minute as 0.1mm in diameter. If multiples are required, a long block of wax is used allowing many of the same patterns to be cut and cast together in a regimented line. Other RP machines are used to create accurate and highly detailed master patterns. From a CAD file, Solidscape prints liquid wax (similar to an inkjet printer) to build and form master patterns. Alternative Rapid Prototype systems build a pattern in very thin layers of resin, resulting in a master pattern from which a cold cure mould can be made. This enables the production of many multiples using the lost wax process of casting from a single RP pattern. (For more details on computer aided design and computer aided manufacture, *see* Chapter 7.)

Silver model of Galleria Colonna by Padgham and Putland.

■ MANUFACTURING TECHNIQUES, METHODS AND PROCESSES

Fabrication in sheet

Sheet silver may be used to form a variety of shapes and structures. The silver model of a luxury ship has been crafted mainly from sheet silver. Starting by shaping and perfecting the hull, the deck levels were built up, again in sheet silver, with the finer details being applied later in the process. Some of these were cast after metal master patterns had been made, so they could be reproduced in quantity. This model was assembled using bolts that go from underneath the detail on the top deck, through the ship's hull, and onto support struts that travel through and into the wooden base.

Two views of a silver model of a luxury ship by Padgham and Putland.

MANUFACTURING TECHNIQUES, METHODS AND PROCESSES

Master pattern making in clay, Milliput or wax

Using hard wax or modelling clay to carve or form a master pattern, a cold cure silicone mould can be created and the items reproduced in quantity by lost wax casting. If you need just one cast from your pattern and use the correct type of wax (such as File-a-wax), you can take this directly into the lost wax cast process for casting. (The important thing to remember here is that if the cast does not come out successfully, you have lost your master pattern and will therefore have to create another one!) Great care should be taken to get all the detail you require in your wax or clay model because once it is cast in metal it is much more difficult, more time consuming and less economic to take to completion.

Chasing over a casting from your master pattern is sometimes still necessary to re-establish the clarity and sharpness that you had in your master, but this very much depends on the quality of the casting. However, it is fair to say that the considerable advances in technology have greatly improved this process: castings are now infinitely better and therefore the accuracy and detail invested in a master pattern is translated much more effectively through to the cast.

Models of a Saracen and a Knight by Gavin Haselup.

Millennium bowl by Toby Russell, polished by Reg Elliot. Courtesy of The Goldsmiths' Company.

CHAPTER FIVE

POLISHING AND FINISHING

Many in the profession regard polishing as a 'make or break' specialist aspect within the craft of silversmithing and jewellery making. If done well it can enhance and expose super qualities within a design; it also enables a skilled and experienced polisher to magnify and celebrate a piece of fine craftsmanship in a piece of silverware. Equally, if work is poorly made and/or badly polished this will immediately be apparent and dramatically reduce the visual impact and aesthetic strengths of a finished piece. Although basic and preparation polishing is regularly undertaken by silversmiths themselves, without exception designers, makers and companies cannot do without this specialist aspect of the craft. There is no real mechanical alternative for polishing and finishing large-scale products by hand, and (unlike with jewellery, for example), technology at present is not having an impact on this age-old and irreplaceable traditional technique. There is nothing quite like a beautifully polished piece of silver, or a piece in which various surface finishes (such as butler, satin, directional, brushed, burnished, flick mop and frosted) are able to offer contrasting and complementary effects.

Perhaps we all like to think we can polish our own work well, but in the wrong hands and without the knowledge, expertise and experience, polishing can impair and even ruin a piece very quickly. Unsurprisingly, therefore, our advice would be always to invest in the skills and services of a highly regarded polisher. An established professional polisher will have undertaken a three-year apprenticeship, in addition to their many years of experience, to offer a top-quality service to the industry.

This specialist craft is potentially hazardous; safety is key, and full concentration must be maintained at all times when polishing. It is imperative that you understand and implement the correct polishing techniques to ensure you polish without incident or accident. Silver is one of the best conductors of heat and therefore work becomes hot quite quickly; this needs to be factored in when polishing. You must never allow an edge on a piece you are polishing to get near to the rotating mop. This can only be done safely when the part of the piece that you are polishing is between you and the mop.

It is also important to use the correct sequence of polishing mops and compounds throughout the various stages of polishing. Constant cleaning of the mops by raking them, as illustrated, is essential; this avoids contamination between compounds, retains a mop's shape, and without doing this you will not be successful in achieving each level of refinement and finish.

To give you an idea of what is involved we visited Elliot & Fitzpatrick, a highly respected polishing and finishing company in London. The following image sequence outlines the key stages of polishing and finishing. Alan Fitzpatrick polishes one of the beakers that we spun in Chapter 4, taking the outside surface to a high lustre polish. The stark difference between the spun and polished finishes can be seen on pages 112–117. The inside and base of the beaker received a brushed satin finish, and there is an additional demonstration of how to use and achieve a steel flick mop texture effect on the base.

During the brushing process the beaker needs to be constantly moved, allowing even removal of the manufacturing marks and ensuring that you are not creating any new marks as you polish. Emery compound mixed with grease is applied to the bristle mops. The whitening process is used at this stage to show up any remaining manufacturing marks as well as to remove unwanted emery compound, which can mask the surface areas you need to scrutinize. Felts are used to eliminate file and spinning marks. Because it is a hard material, this helps to maintain flat surfaces, shapes, sharp edges and forms. The polishing compound Tripoli is used with all felt mops.

POLISHING AND FINISHING

A stapol mop is first used on the outside of the beaker. As with every mop, this has to be racked clean to ensure any previous polish and metal particles are removed. When polishing, the direction of mopping has to be constantly changed to help remove and finally eliminate the manufacturing marks and to avoid polishing drag marks.

The final stage of polishing the outside can be done by holding the piece with tissue paper to avoid putting finger marks on the highly polished surfaces. It is advisable to use a material that will tear away if caught by a rotating mop. (It is true that many professional polishers use leather to absorb the heat generated from polishing but we would not recommend this without experience and confidence.) When polishing areas of flat sheet a supporting board enables safe, secure and proficient results.

1. Polishing workshop of Elliot & Fitzpatrick.

2. Bristle cup mop and emery compound.

3. Brushing inside.

POLISHING AND FINISHING

4. Applying whitening and water.

5. Base and cup brushed.

6. Bristle brush and emery compound.

7. Brushing the inside of the top edge.

8. Felt mop and Tripoli compound.

9. Felting the upper lip.

10. Felting the vertical lip.

11. Stapol mop and carbrax compound.

113

POLISHING AND FINISHING

12. Starting to polish the outside.

13. Polishing in different directions.

14. Stapol polishing complete.

15. Raking/cleaning out the mop.

16. Stitched mop and Hyfin compound.

17. Polishing the inside top edge.

18. Polishing with a large stitched mop.

19. Polishing in different directions.

POLISHING AND FINISHING

20. Continuing with the stitched mop.

21. Stitched mop polishing complete.

22. Felt mop and tripoli compound.

23. Felting the top edge.

24. Felting the base.

25. Base felting complete.

26. Applying whitening and water.

27. Final brushing.

115

POLISHING AND FINISHING

28. Whitening finish complete.

29. Small climax mop using Hyfin.

30. Large climax mop and Hyfin.

31. Climax and Hyfin stage is complete.

32. Swansdown mop and paraffin.

33. Applying AA finishing rouge.

34. Final polishing.

35. Applying whitening and water.

POLISHING AND FINISHING

36. Final brushing on the base.

37. Process from start to finish.

38. Using a flick mop on the base.

39. A flick mop finish.

40. Ultrasonic cleaning.

Advanced polishing and finishing techniques

The following sequence of images shows shaping and dressing a felt, polishing a paper knife and felting the side of a larger piece. As you can see, a great deal of skill and experience is required in finishing pieces such as these, and should be attempted only when you have sufficient capability and confidence.

In addition to the information we have profiled in this section there is an excellent and very informative DVD on polishing and finishing by Reg Elliot and Alan Fitzpatrick demonstrating polishing processes and techniques. This can be accessed through the Goldsmiths' Company website (see Further Information).

The correct stance and polishing position.

117

■ POLISHING AND FINISHING

1. Shaping the felt with a chisel.

2. Dressing the felt mop with pumice.

3. Applying Tripoli.

4. Paper knife for polishing.

5. Felting blade facets.

6. A different felting position.

7. Felting stage complete.

8. Stapol mop using Hyfin.

POLISHING AND FINISHING

9. Climax mop using Hyfin.

10. Swansdown mop finishing.

11. Polishing completed.

12. Large surface area felting.

13. Cylindrical section felted.

14. Felting square section.

Millennium dish by Jane Short.

CHAPTER SIX

SURFACE DECORATION AND DECORATIVE TREATMENTS

Engraving

The art of hand engraving and carving is as valuable today as it has always been to the silversmith; it is a specialist and highly decorative craft, combining art and fine cutting for lettering, lines and patterns, pictorial and textural detail. Engraving transforms the surface of silver designs, whether in the form of wording (to identify a success, event, award, and so on) or image representation (a portrait, illustration or landscape scene, for example). Very little has changed down the centuries with this decorative craft skill and, rather like chasing, an engraver needs to have an understanding of and affinity with art, style and three-dimensional form, as well as control and mastery of the engraving skills.

Hand-cut engraving runs successfully across traditional and contemporary silver design and is in constant demand for its visual language and quality effects, providing a distinctive, 'one-off' quality that sets it apart. Branded as a traditional part of the precious metals industry (and despite technological advances in this area) engraving will continue to be popular because it offers something unique and captivating. Skilled engravers can and will be part of future developments in the profession and, like spinning and chasing, the art of hand engraving is alive and will survive regardless of technological innovations.

The sequence of images below gives an insight into the operation of hand-cut engraving. The shots were taken at Sam James Ltd, London-based engravers. The photographs show James Neville taking us through the processes involved to engrave a script-style letter 'S' on the beaker that was produced in the spinning section of the book. In the hands of an expert, James makes this look very easy and straightforward but just a few words of caution here: engraving tools must be sharp to be effective so are liable to cause injury if used inappropriately or incorrectly. Care must therefore be taken to use the correct techniques throughout all stages of hand-cut engraving. Please take particular note of the position of the hands in the illustrations; James's thumb acts as a guide when cutting with the graver, and a finger serves as a safety stop in the event of any potential slipping when cutting.

Engraver's workbench and tools.

■ SURFACE DECORATION AND DECORATIVE TREATMENTS

1. Matting the surface with plasticine.

2. Pencil guidelines.

3. Marking out the letter.

4. Scribing in.

5. Ready for engraving.

6. Cutting commences.

7. Initial lining out.

8. Leaning the tool over.

SURFACE DECORATION AND DECORATIVE TREATMENTS

9. Continuing to accentuate.

10. Further cutting.

11. Multi-line cutting.

12. The finishing touches.

13. Inspection.

14. The engraving is complete.

15. The engraver's kit.

16. Additional hand-cutting tools.

123

■ SURFACE DECORATION AND DECORATIVE TREATMENTS

The copperplate sample helps to illustrate how flowing graceful lines and patterns can decorate and adorn a surface area. To further inform (and also to set a benchmark of excellence), the portrait of the tiger engraved on steel by Samantha Marsden is included; the final example is the staggering engraving of the House of Lords Casket. This exceptional piece of work captures everything that you would like to see in a pencil illustration or fine painting, but on metal! It took Samantha three months to complete this masterpiece.

17. Sharpening stone.

18. Engraver's workshop/studio.

19. Air-powered engraver.

20. Plate engraving.

An example of hand-cut engraving on copper.

Advanced engraving skills on steel by Samantha Marsden.

124

SURFACE DECORATION AND DECORATIVE TREATMENTS

The House of Lords Casket, engraved by Samantha Marsden, designed and made by Richard Jarvis.

125

■ SURFACE DECORATION AND DECORATIVE TREATMENTS

Both examples by Samantha Marsden (née Johnson) demonstrate the engraver and artist working in total harmony. They show how engraving gives exceptional detail, depth, clarity, fineness, artistry and complexity. To be able to relay perspective, depict character, nature, light and shade, and to represent materials like wood, stone and fabric, is astonishing and brilliant. In 2002 the House of Lords Casket won the prestigious Jacques Cartier Memorial Award for outstanding and exceptional craftsmanship in the Goldsmiths' Craft and Design Council Competition in London. It is a perfect way to promote what engraving is about and the contribution it makes to silversmithing. From this example alone it is easy to see that engraving will always appeal and be in demand in silverware design.

ABOVE AND BELOW: **Steel plates carved by Malcolm Appleby.**

Carving

Carving, a separate and demanding craft skill in its own right, provides the opportunity to cut and sculpt deeper and further into the gauge of metal. This greater physical depth creates a foundation of layers and form for engraving and finer carving to follow. In the hands of an expert the resulting three-dimensional presence and visual communication is striking and unique. Though it is not an easy skill – a small percentage of engravers venture into the carving and sculpting arena – the benefits and rewards from such indulgence can be remarkable.

As you can see from the illustrated examples by Malcolm Appleby (a master in this field), flat metal surfaces really come to life and it is difficult to see how this could be matched by any other cutting process and technique. The purist would endorse that machines and technology are not able to replicate or capture the human feel and convincing nature of hand carving and engraving. A heavier and more robust approach is required for the process of cutting and removal of metal, often involving the use of hammers and chisels, and requiring a fair degree of force and strength.

Silver vase by Yumiko Iijima.

SURFACE DECORATION AND DECORATIVE TREATMENTS

Computer engraving

In total contrast to hand engraving but very much a reality in the commercial world, computer engraving is popular, applicable and highly cost-effective for a high percentage of production engraving requirements in the industry. As in so many cases where technology has developed within a profession, machine engraving by pantograph has to a large extent been superseded by computer engraving, and the example here illustrates the precision cutting that this service provides for lettering and patterns.

Computer engraving offers a comprehensive range and variety of cutting, and it is easy to see why it is so widely used across a large range of products, plates, regalia, trophies, and so on. This mechanical and accurate cutting doesn't pretend to be superior or to challenge the beauty and uniqueness of hand-cut engraving, but it offers a quality service in its own right. So, happily, both are available to suit our individual needs, whether we are working to budget and commercial constraints or we are hand-engraving one-off pieces.

Computer engraving machine at R.H. Wilkins.

Computer engraving.

An example of basic cutting with computer engraving.

127

■ SURFACE DECORATION AND DECORATIVE TREATMENTS

Enamelling

The art of enamelling has been practised since ancient times and it is as popular today as ever. The decorative qualities and spectrum of colours give designers a wonderful opportunity to decorate surface areas on silver vessels in a distinctive way. In traditional vitreous enamelling, special glass is ground to a fine powder, cleaned, applied to silver surfaces, fused in a kiln, ground and then flash fired. This brief description of the process masks the complexity involved in mastering this specialist aspect of the craft.

From this fundamental beginning designers have developed and perfected their own style and identity through enamelling. We have selected three world class experts to show how silverware can be enhanced by decorative and beautiful enamelling, portraying abstract art, design and nature and much more.

Jane Short

Jane specializes in champlevé and basse-taille enamelling using colour and imagery in a unique way, as typified in her Millennium dish shown at the beginning of this chapter.

Feathers vase by Jane Short.

SURFACE DECORATION AND DECORATIVE TREATMENTS

Celebration dish by Jane Short.

Fred Rich

Fred's depiction of nature is unrivalled, and these examples show artistic perfection in enamel using the cloisonné technique. Abstract design is another aspect within his portfolio.

Enamelled ewer by Fred Rich.

SURFACE DECORATION AND DECORATIVE TREATMENTS

Mermaid salt by Fred Rich.

Leaping salmon beaker by Fred Rich.

Phil Barnes

Phil's forte is in champlevé enamelling where he carves into the metal and follows this with fine engraving to establish decorative designs that receive transparent enamel.

Silver bowl by Phil Barnes.

Beaker, lid and saucer by Phil Barnes.

SURFACE DECORATION AND DECORATIVE TREATMENTS

Silver table salt cellar by Phil Barnes.

Chasing and repoussé

Chasing is one of the important allied crafts to silversmithing and offers great diversity of expression through the creative movement and manipulation of metal. It is the opposite technique to repoussé, and the two are used in conjunction to create form, pattern, detail and expression on a finished piece. Repoussé is working on the reverse of the metal to transmit a design through to the front. Chasing is used to manipulate, nurture and refine a design, predominately on the front face by sinking and dressing down the metal.

Chasing and repoussé exploit the malleable qualities of precious metals but particularly silver. By the very nature of these techniques the metal is constantly being moved around and hammered, but there is no loss of metal or its weight in this process. It is stretched and thinned according to the amount of treatment and depth of a design, but the metal remains as one continuous surface. However, great care is needed when working on high relief designs because the metal will be stretched to extremes, so it can crack, tear or split, and this is usually at the deepest part of the design.

Very much like a planished finish, the tooling and direct contact between the steel chasing punches and the metal surface gives a hammered finish that is unique to this traditional technique. Because this is the way that most chasing work is finished, it also defines the character, quality and technical/creative talent achieved on a given piece of work. This of course is distinct from many other techniques where the working methods are somewhat masked or eliminated when taking a design to completion (filing, sanding, stoning, etc.).

Chasing requires only basic tools but great handcrafting skill and an affinity with art and design to produce work that is of a high technical and artistic standard. A simple cast-iron

The chaser's tools.

SURFACE DECORATION AND DECORATIVE TREATMENTS

pitch bowl and wooden triangular base should be used when chasing; this enables the metal to be held securely and to be manoeuvred so that you can achieve the best angles and positioning for chasing.

A number of chasing hammers of varying weights are available from tool suppliers and what you select should depend on the force required to move and manipulate the metal you are using. Chasing punches are usually made by the silversmith/chaser, using tool steel to suit the various different design shapes, sizes, details and textures that you will need. Your collection will keep increasing as you find the need to make more punches to suit individual shapes and requirements in your work. These steel punches, once shaped, need to be hardened and tempered before using. The photograph above shows a fine collection of chasing punches, hammers, and a pitch bowl without the pitch material in it.

When preparing and setting up a pitch bowl for the first time it is best to half fill it with concrete or stone to establish a solid, heavy base and to keep the pitch material to the top half of the pitch bowl only. The pitch itself needs to be hard enough to withstand the hammering action of the chasing process but also have some flexibility to hold and absorb the chasing work, especially if fine detail is required. Firm resistance when pushing your fingernail into the mixed cold pitch is a good test of its suitability and readiness.

Chasing pitch in block form can be purchased from your jewellery/silversmithing tool supplier. Extreme care and

Hand and tool positioning for chasing.

ABOVE AND BELOW: **Gavin O'Leary teaching chasing to apprentices, Goldsmiths' Centre, London.**

SURFACE DECORATION AND DECORATIVE TREATMENTS

Repoussé hammering by Wayne Meeten.

Low relief chasing offers a good opportunity to tell a story or portray detailed artwork. A fine example of low relief chasing by Rod Kelly is shown below.

Low relief chasing by Rod Kelly.

Hand and tool positioning for chasing (*continued*).

attention is needed when melting pitch with an open flame or gas torch as it can cause severe burns if it comes into contact with your skin. It is always necessary to wear safety equipment and clothing, including glasses, full face visor and heat resistant gloves, leaving no skin exposed. It is also sound practice to set up a separate fume extraction area when heating and melting pitch and to keep the area as clean as possible.

SURFACE DECORATION AND DECORATIVE TREATMENTS

Line and form chasing by Zoe Watts.

Deep chasing by Miriam Hanid.

Miriam's design above illustrates how such bold and expressive movement can be achieved from chasing. This piece is a fine example of working a traditional technique to great effect and transforms a surface area into a dynamic statement of personal identity.

Etching

Decorating metal surfaces by acid etching continues to be a popular method of applying further interest and appeal to designs. This process offers the freedom to create any desired artwork or pattern; it can be free-flowing and organic through to geometric and regimented – basically anything to suit – and the designs included in this section reflect this.

This is a nitric acid erosion process and as such, caution needs to be exercised, therefore we advise you to comply with current health and safety standards.

Etched silver bowl by Karina Gill.

Droplet silver beaker by Sian Matthews.

134

SURFACE DECORATION AND DECORATIVE TREATMENTS

Organic pattern bowl by Sian Matthews.

Photo chemical etching

Photo chemical etching is a precise, cost-effective technology that is used within silversmithing. This is highly suitable in cases where accuracy and repetition are required, for example in architectural modelmaking, as well as in creating cells for enamelling.

The range of work that is appropriate for etching can be from simple, elegant shapes to highly complex pierced and filigree patterns, which can also incorporate other decorative treatments such as engraving. This process is burr- and stress-free and can be applied to a number of appropriate materials, in thicknesses from 0.025mm to 1mm.

The examples of photo chemical etching shown illustrate the fineness, repetitive and accurate work that this service provides. Images are courtesy of Chempix Ltd.

Photo mechanical etching process.

ABOVE AND BELOW: **Photo etching by Chempix Ltd.**

Paper knife by Jack Row.

CHAPTER SEVEN

TECHNOLOGY IN A TRADITIONAL CRAFT

Recent practice in design and manufacturing reveals a traditional craft taking on and fostering aspects of technology, some of which work in combination with hand crafting techniques and production processes. There is no doubt of the need to integrate certain technological developments within silversmithing, and in general these have been embraced by practitioners. Some say, and perhaps quite rightly, that this impressive technology should be seen as another specialist tool for craftsmen to work with, develop and perfect. But as these advances continue to make further inroads into the industry, in many cases technology will carry, lead or even dominate future business operations.

Evidence of this is easy to see and there are some fine examples of contemporary technological developments making a positive impact in the precious metals profession. Unsurprisingly, jewellery leads the field in this area, but this chapter gives some excellent individual case studies across a range of technologies, and in every instance good design is ever-present and promoted extremely well. Some of the many positive ways in which a traditional craft can successfully work in tandem with technology are illustrated here; also demonstrated are ways in which new technologies are making their mark and gaining their own identity through the extreme complexities and technical feats that are being attempted, advanced, and successfully delivered.

Undoubtedly, new technologies have raised the bar and extended possibilities, degrees of ambition and the levels of technical excellence within silversmithing, and the opportunity to harness this exciting arm of the craft is there for all to explore. A staunch traditionalist might view this in a negative light – as an attack on their sacred handcrafting skills, perhaps – but the majority recognize the wider opportunities and capabilities. We believe this marriage of old and new is a dynamic and powerful force in silversmithing, and as collaborative partners the craft has never experienced this strength and potential before. The technical feats that are now possible offer uplift and enhancement, which could be a supporting factor to the future health and wealth of the precious metals profession; perhaps this is the best way to evaluate the impact and implications of the technological developments now firmly embedded in silversmithing.

As previously mentioned, the main focus of this book is an understanding of the core, fundamental aspects of silversmithing; equally, however, we feel it is extremely important to be aware of, and where appropriate, to participate actively in any arm of technology that supports, promotes and enhances one's work.

The following pages therefore portray a positive account of technology covering aspects such as computer-aided design (CAD), rapid prototyping (RP), laser sintering, casting, laser and water-jet cutting, and computer-aided machining (CAM). The chapter is image-led and helps the reader to discern some of the detail involved; moreover, in each instance the products feature designers promoting their individual style and identity. This chapter doesn't attempt to cover every aspect of technology but merely seeks to inform, educate, and inspire.

Grant Macdonald Silversmiths: CAD, RP and laser cutting

One of the silversmithing and goldsmithing companies that has led technology from the front is Grant Macdonald, a pioneer of laser cutting when the technology began to enter the precious metals profession. To demonstrate this, we use an exquisite example of 3D laser cutting that challenges the skills of hand craftsmanship with its complexity and technical

■ TECHNOLOGY IN A TRADITIONAL CRAFT

demands; perhaps sceptics may be convinced that this is where technology can deliver professional outcomes that are hard to match by hand crafting methods.

Equally impressive has been the constant investment in time, resources, research and development in computer aided design, rapid prototyping and high-tech casting. The outcome from this long-term commitment is evident in high-quality products where it is difficult to see how they could be replicated or even challenged by conventional methods. These are surely fine examples of added value to silversmithing, and also put a marker out for potential use in silver design.

This company has successfully gone through a transition from work produced by hand crafting techniques to a high percentage of components designed and produced using technological processes and techniques – almost exclusively in house. To illustrate the main stages of production we have selected a pair of salt and pepper pots, which demonstrate the sort of work, quality and utilization of technology used in the manufacture of such state-of-the-art products.

1. Checking and finishing drawing.

2. CAD with supporting framework.

3. Extruded rapid prototype.

4. Preparing for spruing.

5. Sprued and ready for investment.

TECHNOLOGY IN A TRADITIONAL CRAFT

The second design captures a rapid prototype extruded from the liquid resin, which is taken through to be vacuum cast. This technology, together with the spinning process used for the salt and pepper pots, demonstrates how a hand production process can be successfully combined with technology in a powerful statement.

6. Cleaning up from casting.

7. Salt and pepper pots, designed and produced using CAD, RP, casting, spinning and finishing techniques.

8. Pattern created from liquid resin.

9. The cast model.

139

TECHNOLOGY IN A TRADITIONAL CRAFT

LASER CUTTING

Cutting accurate patterns through laser technology has been an established practice since technological developments started making their mark in the creative industries. The range and capability of laser cutting seems to have no boundaries; it offers sharpness and incredibly delicate cutting, including tight corners – a clear advantage by direct comparison with its technological partner, water-jet cutting (*see* page 163).

The facility is highly suited to quantity production runs, and the capital investment required for the plant to operate laser cutting somewhat dictates this. Taking this further and looking at the formidable capability of 3D laser cutting, this has to be the ultimate condition for unit pricing and offsetting this against high volume production runs.

The two examples here show some early laser cutting on the flat followed by a stunning statement of 3D cutting that seems to defy logic and reason and could not be successfully replicated and matched by the conventional hand-pierced methods.

Elementary laser cutting by Grant Macdonald.

The Queen's Golden Jubilee bowl – a superb example of 3D laser cutting by Grant Macdonald.

Jack Row: computer aided design, rapid prototyping and casting

Young designer-maker Jack Row is fully embracing technology in his work and in particular with the luxury pens that are featured here. His neat, accurate and meticulous craftsmanship is ideally suited to these technological processes with their exacting tolerances. This example demonstrates how CAD, RP and then induction/vacuum casting can produce top level accuracy throughout an open and complicated three-dimensional structure; these units would be difficult to produce in 18ct gold by hand (particularly series production). The images in this feature have been supplied courtesy of Weston Beamor and Jack Row.

The following image sequence illustrates the various stages of preparation and finishing required to take the pen frame

TECHNOLOGY IN A TRADITIONAL CRAFT

1. CAD model ready for rapid prototyping.

2. Arranging components.

3. Resin being cured by UV laser beam.

4. Viper RP equipment.

141

■ TECHNOLOGY IN A TRADITIONAL CRAFT

5. RPs and support resin completed.

6. Pen components extracted.

7. Sprued up for investment.

8. RPs invested in plaster.

9. Burning out wax.

TECHNOLOGY IN A TRADITIONAL CRAFT

10. Vacuum induction casting machine.

11. Casting grain into crucible.

12. Cast completed.

13. Removing the flask.

14. Cast component.

from cast to completion; with the exception of the laser welder (used to correct any imperfections from the casting process), they demonstrate hand finishing techniques.

These finished articles typify, celebrate and promote the values of working with computer aided design, rapid prototyping, induction casting and laser sintering in combination with accuracy and engineering precision; quality statements using technology to great effect.

■ TECHNOLOGY IN A TRADITIONAL CRAFT

15. Laser work to correct any defects.

16. Refinement with wet and dry.

17. Further refinement using micromesh.

18. Round detail being prepared.

19. Polishing round surfaces.

TECHNOLOGY IN A TRADITIONAL CRAFT

20. Felt mop polishing.

21. Final lustre polish with rouge.

22. Inner areas are thread polished.

23. CAD, RP and casting successfully integrated in Jack's design.

145

■ TECHNOLOGY IN A TRADITIONAL CRAFT

Another example of the use of technology.

This outer frame has been created by laser sintering titanium.

Martyn Pugh and Dr Ann-Marie Carey – laser and TIG welding

Each individual profile in this chapter has helped to highlight an eclectic group of designers who share a common passion and desire to seek new territory, work with and harness technology and achieve new goals. This feature on silversmith Martyn Pugh reveals something special and unique, as we shall see; it is also a fine example of excellent collaboration and team work with Dr Ann-Marie Carey and a research team from Johnson Matthey. Together their collaborative and pioneering work has made a significant contribution in experimenting with and exploring the potential of laser, but particularly TIG welding applied to silver components in the manufacture of silverware products.

Their exclusive research over the last ten years has been refreshingly inventive and willing to take risks, and the collective outcome has resulted in Martyn integrating laser and TIG welding into his mainstream manufacturing techniques and processes, particularly in his larger-scale work. This learning, experience and his findings have been presented in papers in America and in the UK and Europe; we have been fortunate to see some of his results first hand. Research and development is viewed by most as necessary and essential, but to witness the fruits of this considerable and sustained period of investigation being positively channelled into Martyn's design-led silversmithing surely justifies the time and effort invested over these unique and bespoke projects.

Therefore, and firstly, we have assembled a collection of images that give an insight into the innovative use of laser welding in the making of his micro-alloyed 99 per cent gold, 1 per cent titanium (990 gold) 'Sun' claret jug. In order

TECHNOLOGY IN A TRADITIONAL CRAFT

Laser welding trials. (Photo: Dr Ann-Marie Carey)

Partly dressed laser welded seam. (Photo: Martyn Pugh)

Checking clearance in laser chamber.
(Photo: Dr Ann-Marie Carey)

Additional metal lasered on. (Photo: Dr Ann-Marie Carey)

Spun sections lasered together. (Photo: Dr Ann-Marie Carey)

Laser repair to handle seam. (Photo: Dr Ann-Marie Carey)

147

■ TECHNOLOGY IN A TRADITIONAL CRAFT

Cast foot collar – laser repair flaw.
(Photo: Dr Ann-Marie Carey)

Laser repair to surface flake on spout.
(Photo: Dr Ann-Marie Carey)

to achieve his goals, Martyn Pugh used a team of technical experts including Johnson Matthey (JM); Dr Ann-Marie Carey (AMC), Jewellery Industry Innovation Centre (JIIC), Birmingham City University (BCU); Kevin Grey (KG) and himself (MP).

With the inherent learning from the 'Sun' claret jug, Martyn and the team then embarked on their next challanging assignment, the claret jug again but this time in palladium. This is where TIG welding came into its own and it proved to be crucial for strength and sustainability when spinning the palladium cones into the sectional shapes of the jug. It was the combination of laser and TIG welding that made the project an unequivocal success in tandem with a dogged determination to push boundaries and overcome any obstacles. On a project of this nature one would expect to encounter technical and physical problems en route. With palladium being the most recent precious metal to receive its official hallmark, this case study should be judged as an original footprint of individuality with technology playing a crucial part in its successful development and resolution.

Martyn has utilized the outcomes of these research projects into his mainstream silversmithing designs, and the images in this section illustrate tig-welding silver components together, with the finished silver Jug boasting invisible seams from using this method by comparison to conventional soldering.

Martyn's technical drawing. (Photo: Martyn Pugh)

TECHNOLOGY IN A TRADITIONAL CRAFT

JM's technical version. (Photo: Johnson Matthey)

Spinning chucks. (Photo: Johnson Matthey and Martyn Pugh)

149

■ TECHNOLOGY IN A TRADITIONAL CRAFT

TOP LEFT: **Pie-shaped spinning blanks.**
(Photo: Johnson Matthey)

TOP RIGHT: **JM spinning the jug profile.**
(Photo: Johnson Matthey)

LEFT: **TIG welding cones for spinning.**
(Photo: Johnson Matthey)

Spun and TIG-welded jug components. (Photo: Johnson Matthey)

TECHNOLOGY IN A TRADITIONAL CRAFT

Close-up of TIG-welded seam/joint.
(Photo: Johnson Matthey and Martyn Pugh)

Close-up of spot welds. (Photo: Dr Ann-Marie Carey)

Base of foot, preparation for laser welding.
(Photo: Dr Ann-Marie Carey)

Disguising the seam by adding metal.
(Photo: Dr Ann-Marie Carey)

Weld spots prior to soldering. (Photo: Dr Ann-Marie Carey)

Soldering the handle onto the neck. (Photo: Martyn Pugh)

151

TECHNOLOGY IN A TRADITIONAL CRAFT

Assembled claret jug body. (Photo: Martyn Pugh)

Martyn's finished palladium and gold claret jugs.

TECHNOLOGY IN A TRADITIONAL CRAFT

TIG welding silver. (Photo: Kevin Grey)

TIG welding silver. (Photo: Kevin Grey)

TIG-welded seams.

Invisibly seamed jug.

153

■ TECHNOLOGY IN A TRADITIONAL CRAFT

Kevin Grey – laser welding

The word 'unique' is rather overworked these days, but in this instance it is perfectly apt, as we profile a designer who has led the way in using laser technology through his designs for silversmithing. There is simply no one else out there doing this style, type and complexity of construction work in the craft. Crossing industries has played a part in Kevin's development (before becoming a silversmith he worked in the luxury automotive industry, making bespoke pieces for Bentley, Rolls Royce and Morgan) and this catalyst has unlocked talent, in combination with precision and technology, to superb effect and to his own personal advantage.

Most, if not all, experienced craftsmen using conventional methods of manufacture would judge these designs extremely difficult to fabricate, and perhaps some would tend to avoid taking on such a challenge by choice. This fine example of contemporary and technological craftsmanship is respected and admired by senior trade craftsmen. Kevin has extended the range of possibilities in what can be explored, pioneered and mastered in silversmithing.

In summary, creative talent harnessing modern technology and chanelling it into unique designs in silver has added and enhanced the palette of distinctive and high quality work. We are fortunate to witness such movement and direction within the profession that not only holds onto its origins but seeks to move with the times.

In addition to his totally handmade and large-scale silver work, Kevin also produces a range of smaller pieces, which he has adapted and developed to be suitable for lost wax casting. This obviously extends his portfolio of work and enables Kevin to build a more comprehensive portfolio.

Kevin has also continued to explore the use and potential of tig welding. He has developed and perfected this difficult technique, enabling him to make larger scale silversmithing. The images in this section illustrate tig welding that has been exclusively used throughout the design; there is no conventional soldering or even laser welding on the piece. As a pointer to its size, look at the former in the background in picture 13 in this sequence.

1. Components of bowl and former.

2. Fitting strips for welding.

3. Tacking strips for welding.

4. Laser welded joint.

TECHNOLOGY IN A TRADITIONAL CRAFT

5. Sections welded together.

6. Applying units to former.

7. Building of units continues.

8. Side view of emerging form.

9. Welding in the laser machine.

10 & 11. ABOVE AND BELOW: Design-led silversmithing fabricated exclusively using laser technology.

12. Other exquisite designs exploiting laser welding.

■ TECHNOLOGY IN A TRADITIONAL CRAFT

Kathryn Hinton – CNC milling and press forming

The high-tech processes and techniques used by Kathryn Hinton to produce her multi-faceted silversmithing designs are, we believe, unique to Kathryn, even though stamping by hand, using a fly press, and hydraulic forming have been, and continue to be, part of hand and production processes. This case study shows how a fresh and different approach to creating large-scale press forming is channelled into Kathryn's silver designs.

The piece starts life as a CAD file, which provides the essential CNC (computer numerical control) toolpaths for cutting the two moulds in polyurethane. A CNC three axis machine cuts the male and female moulds over three stages with a 6mm, 3mm, and finally a 1mm cutter, into polyurethane blocks. Once this process is complete, Kathryn anneals her Britannia silver sheet and starts the pressing stages using a 20-tonne hydraulic press to achieve the definition on all facets in her design. The finished outcome is achieved by pressing only – the facets are not touched by hammer at all – and even using Britannia silver this is quite some feat. This is ground breaking work by a designer who seeks to be different in harnessing technology to her advantage.

13. Stages of TIG welding – 1.

14. Stages of TIG welding – 2.

15. Form, contrast and a unique design, utilizing technology.

1. Male and female CAD images.

156

TECHNOLOGY IN A TRADITIONAL CRAFT

2. First cut of polyurethane former.

3. Finishing cut of female press former.

4. Finishing cut of male press former.

5. Hydraulic press forming in progress.

6. Completion of pressing and forming.

7. Finished and polished Britannia silver dish.

■ TECHNOLOGY IN A TRADITIONAL CRAFT

Although a familiar process to many, Kathryn is taking her own route in designing and exploiting ideas for small-scale silver designs. The images below perfectly demonstrate a designer working and using CAD, rapid prototyping and casting in her own style and visual territory. This begins life on the computer with a flat digital mesh where points are formed into a bowl shape using a digital hammering technique developed by Kathryn. The resulting design is built on a high precision 3D printer and then taken through to be cast. As with Kathryn's press forming work, her quest to explore design through technology is there for all to see and acknowledge.

Sterling silver cast bowl.

ZBrush CAD image of digital mesh.

Rhino CAD Image.

Simon Ottaway – CAD and CAM

Computer aided design in partnership with computer aided manufacture is another valuable arm of technology that is being fostered and exploited in silversmithing. It offers fine detail through accurate milling/cutting on wax and metal, and this precision and intricacy is ideal when repeat patterns within a design are required. This manifests itself perfectly in the specialist area of model making, where silversmiths take on commissions to fabricate buildings, models, structures, etc. CAD/CAM is extensively used in many industries, but watch-making is a very good example, demanding top-flight precision and accurate detail in production mode.

Silversmith Simon Ottaway has developed his skills and business in CAD/CAM and offers this as a valuable service to the precious metals profession. The example included in this section demonstrates the fine detail and repetitive patterns that are required when making an accurate replica of an architectural building. In this instance it is cut into wax and the resulting cut pattern is then ready to be taken through the casting process to produce the cast silver panel of a historic building in Rome.

The image sequence helps to illustrate the capability of this technology and how it can play a major role in this type of construction work.

TECHNOLOGY IN A TRADITIONAL CRAFT

1. CAD image of model.

2. CAM image of model.

159

■ TECHNOLOGY IN A TRADITIONAL CRAFT

3. Micro milling machine.

4. Wax cut, clamped and ready for milling.

5. First cut preparation.

6. Surface machined ready for detail.

7. Lubricant applied to aid cutting.

8. Cutting of fine detail.

9. Cut and ready for cleaning.

TECHNOLOGY IN A TRADITIONAL CRAFT

10. Prepared for casting.

11. Silver cast component.

12. Panels completed and being assembled.

■ TECHNOLOGY IN A TRADITIONAL CRAFT

13. Model in construction.

14. The finished article by Padgham and Putland.

TECHNOLOGY IN A TRADITIONAL CRAFT

SCISS: WATER JET CUTTING

This arm of technology has been available as an accurate cutting service to industry for many years and it continues to play an important part within the precious metals profession. Running as a parallel service to laser technology, precision water jet profile cutting offers high pressure, accurate cutting on a wide range of materials. It can do this on thin and thick gauges and this abrasive erosion process leaves a virtually burr-free finish; the level of detail and refinement that can be achieved is truly remarkable.

In crude terms, water is combined with an abrasive compound (crushed gemstone, usually garnet) and forced into a very small jet (0.6/7mm) at a very high pressure (55,000 psi) to generate a high velocity jet that cuts into a material. Very little heat is transferred onto a material in the cutting process so there is little or no heat colouring, melting, hardening, heat distortion etc. Water jet cutting is particularly useful for cutting thick materials and it offers five cut qualities to suit a variety of needs and surface finishes. There is no tooling change throughout the cutting process and it has a precision tolerance of +/– 0.127mm over 2 metres and +/– 0.08mm over 300mm.

Sciss is a company that specializes in water jet cutting; they offer this specific service to a wide variety of industries and businesses. The images included give you an idea of the range, scale and refinement that they can accommodate and deliver. This is a diverse and comprehensive service that could be appropriate and suitable for your current and future needs.

Samples of water jet cutting.

Water jet cutting equipment.

Stainless steel medal.

Cut and removed.

Water jet in action.

Fine detail on plastic.

Accurate deep cutting.

163

Formula One trophies by Richard Fox.

CHAPTER EIGHT

DESIGNERS IN INDUSTRY

As previously discussed in this book, silversmithing as an industry has undergone some significant changes over the last twenty-five years; established companies have found it increasingly difficult to compete with overseas competition and the world market in general. To succeed and operate through such times has required a flexible approach and willingness to move with the times, embracing change and seeking emerging opportunities.

The following three designers have successfully adopted this philosophy and continue to develop, progress and evolve.

Clive Burr

When viewing his impressive portfolio of work it is clear that Clive Burr has built an enviable reputation as an outstanding craftsman who has the ability and desire to work to the highest standards in professional practice. He produces exclusive ranges, corporate production runs, and prestigious commissions for a clientele list to die for.

Confetti clock by Clive Burr.

DESIGNERS IN INDUSTRY

Candelabra by Clive Burr.

Mace by Clive Burr.

Through his company he leads a small team of specialist craftsmen who collectively design and produce items of goldsmithing and silverware to a high specification and standard. Clive has also perfected the integration of some supportive aspects of the craft: engine turning, engraving and enamelling in particular. These are crafted to equally high standards, forming an unbeatable alliance of first-class making along with beautiful decorative and aesthetic qualities. His longstanding and successful collaboration with master enameller Jane Short is testimony to this.

One of Clive's specialities is his clocks: these generic, clean pieces are exquisite and exude precision and perfection. They comfortably match other products from the past where high-end companies specialized in these fascinating timepieces and works of art. Craftsmanship at its best in this specialist field has helped Clive to build a reputation of international standing.

Further analysis of Clive's work reveals that a high percentage of his gold and silversmithing designs relies on hand making techniques from craftsmen able to take his designs to perfection or close to it. It is therefore necessary for him to call on people who have had the benefit of a traditional training, developed throughout their career, to ensure that quality work is ever present in his workshop. Technology is, and will always be, deployed in the production of silversmithing components and products, but here is a great example where hand crafting skills are alive, healthy and in demand; you could argue that in this instance they are irreplaceable.

To summarize, Clive Burr is a world leader – a great exponent and ambassador of fine craftsmanship and of promoting allied aspects of the craft.

DESIGNERS IN INDUSTRY

Grant Macdonald

Aston Martin cutlery by Grant Macdonald.

Aston Martin bottle cooler by Grant Macdonald.

Goldsmiths' Company Court goblet by Grant Macdonald.

Over the timespan of one's career there are very few people you come across who seem to be continuously successful and are natural entrepreneurs no matter what, but Grant Macdonald has been just that. We have worked and liaised with Grant over many years and in our minds there is no doubt that he is one of the most successful designers operating in silversmithing, goldsmithing and related industries.

For over forty years Grant has led the way in designing and creating commissions and bespoke pieces to an ever-widening international audience. This should be of no great surprise when you reflect on his personal qualities and business acumen. Grant Macdonald could be appropriately described as an astute designer and businessman with the ability to pioneer developments and secure new markets of opportunity wherever they exist.

From early on in the business, and alongside his workforce of skilled craftsman using many of the silversmith's traditional hand making techniques, it soon became apparent that Grant needed to invest in the potential benefits of technology in the production of his designs. This aspect rapidly mushroomed when Grant embraced the services offered by other industries, and in particular, laser cutting, CAD and rapid prototyping.

Never shy of opening new doors, Grant's business continued to search for greater gains, always driven by design and technology and never afraid to invest in order to be ahead of the game. He has pioneered and perfected cutting-edge manufacturing techniques with traditional craft skills, combining them to produce work that has ultimate precision and elegance.

From a foundation in the UK and Middle Eastern markets, Grant Macdonald has built a luxury bespoke service with an impressive international following; it is a global network serving the needs of royal families, diplomats and well-known political figures. Parallel to outstanding craftsmanship his work remains economically competitive on the open world market.

Proof of many of the above plaudits is easy to track, but perhaps his collaboration with Aston Martin may be particularly perceived as an instance where fortune favours the brave. The Grant Macdonald collection for Aston Martin is a perfect example of design, technology, innovation and business conviction. It celebrates a fusion of high-end technology and traditional craftsmanship to create stunning and exclusive silverware for the home, business environment or corporate requirements. Remarkably, in addition to all of this, Grant has also found the time and energy to serve as a Prime Warden to the Goldsmiths' Company.

You might conclude that only a few would follow this individualistic and entrepreneurial route but what a case study to use for anyone with their sights set really high!

Richard Fox

Richard Fox has been successfully running his design-led silversmithing company for some thirty years, and both authors of this book have been fortunate enough to watch the incremental growth, progression and strengthening of his business. Richard has become a branded name and leader in the field of designers, making a significant contribution in the commercial world of industrial design.

Today he offers a wide range of products and items to his corporate clients and individual customers, but equally notable is how Richard has developed an impressive array of facilities and services that he provides not just for his own business, but also as a valuable and attractive range of treatments and services to the industry. These assets, in combination with

Wafer box by Richard Fox.

DESIGNERS IN INDUSTRY

Candleholders by Richard Fox.

his own work, make his practice a distinctive establishment within the profession, and he has clearly identified a number of opportunities for business that feed most effectively into his own portfolio. Richard offers, promotes and delivers hand crafting skills, production processes and technological services that are difficult to find elsewhere under one specialist silversmithing company.

From the core of his silversmithing Richard has pioneered and focused on designs that have enabled him to expand his portfolio into corporate work, ecclesiastical pieces, motorsport trophies and an extensive range of silverware. A good percentage of this is manufactured using production processes like spinning, stamping, electroforming, CAD/CAM and casting. Other supportive technological services developed and perfected include electroforming, CAD/RP, computer engraving, PUK and TIG welding, and electroplating.

Richard's self-sufficient business model is sound, assertive, confident and fine-tuned, and this standalone example of what you can achieve and how you can realize it, is based on a gradual expansion and sound understanding of the markets he has pursued so effectively. His work is taken to exceptional standards of professionalism and he can respond to any area of request and opportunity from his comprehensive and competitive portfolio of work. The morals here for any aspiring silversmith are: to reflect on the values of learning and mastering traditional silversmithing; to research the market(s) thoroughly to establish where potential opportunities may exist; and to build your business around these aspects you are targeting.

To conclude, Richard Fox is an excellent example of what can be achieved; perhaps 'keep it simple and do it well' has been one of his mottoes, helping him to create an international profile and unique business in the industry.

Candle holder by Jenny Edge.

CHAPTER NINE

DESIGNER-MAKERS

This part of the chapter profiles a selection of contemporary designers; many of these beautifully portray particular aspects, processes and techniques of the modern day silversmith. The list of talented designer-makers practising the craft is seemingly endless these days, and it has been rather a nice problem to narrow down our list from such a healthy range and eclectic mix of established designers.

This is a particularly good period in which to collate and reflect on the strength and depth of designer silversmiths operating as sole traders, and this section of the book helps us all to recognize, appreciate and celebrate that silversmithing is very much alive as a creative industry in the twenty-first century. We are indeed extremely fortunate to be able to see this growth, vitality and personal expression, especially when there are so many purveyors of 'doom and gloom' around us, who tend to focus on negativity. There follows some information and visual statements that exude a positive and upbeat account of a vibrant and very proactive community making a positive contribution for those who appreciate and value design that is creative, individual and unique.

Brett Payne

To the best of our knowledge Brett Payne is the only designer-maker in the UK, and possibly Europe and overseas, to be exploiting hot forging as a leading technique in much of his work. These designs are hammered by hand and evidence of this can be seen in sample video clips on Brett's website. His

Hand-forged silverware by Brett Payne.

DESIGNER-MAKERS

ABOVE AND BELOW: **Hand-forged silverware by Brett Payne.**

clean-cut lines, open forms and clever use of counter balance give Brett's designs a generic air of simplicity that befits a contemporary ethos of distinction and universal appeal. In the designer-maker community there is common agreement that Brett designs and creates some excellent silversmithing work, so it is of no surprise that he and his work are sought after and much in demand; he is consistently welcomed and valued wherever he sells his beautiful work.

His recent decision to focus on his greatest love and passion of silversmithing is there for all to see, and wherever you find Brett you will be captivated by his presentation and numerous design combinations. There is more to his work than meets the eye on a first viewing and this simply increases the quality and depth of Brett's designs. It is easy therefore to see how potential customers become rather spellbound about his portfolio, which we believe marks a renaissance in the long-standing traditional technique of hot forging. Brett has really utilized this and taken his work to another level as he continually seeks to explore new applications.

To summarize, Brett's use of traditional techniques, fostered and developed through generic simplicity and driven by developing his own style of contemporary design makes him a fine example of a unique and ambitious designer whose use of traditional aspects of the craft is very much in harmony with the twenty-first century.

Wally Gilbert

Wally is a talented and eclectic designer with many artistic and creative strengths; he provides himself with the time and space to take his ideas into different fields of art, and explores ideas wherever his interests and experiences take him. This admirably fresh philosophy has led to Wally developing a distinctive and individual career, and this rich experience has enabled him to offer and provide a wide choice and combination of materials and processes, including (very importantly) the use of traditional techniques in the manufacture of his designs.

Wally firmly believes in the traditional values of drawing, developing and presenting proposals to his clients, and devotes considerable time to drawing his ideas and producing 3D models. His chasing, modelling and sculpting perfectly demonstrate the breadth of his talent and skills. His work is expressive, bold, detailed and captivating – a fine example of the value of learning a mix of specialist skills that can be beautifully utilized and deployed in silversmithing.

DESIGNER-MAKERS

Wally's work decorates and adorns silverware, his trademark of chasing being especially beautiful and distinctive. He has learnt and developed his strengths by taking a wider look at aspects of art, and has directed these most effectively as a designer silversmith.

Opportunities when presented need to be fully grasped, but there are other instances where an individual has to create a chance, an opening or a possibility. Wally is an excellent case in point: he demonstrates what you can experience, learn and develop by taking such a diverse approach to his work, wherever it might lead him. Here is an exclusive silversmith and broad-based artist who works in different fields, including architectural metalwork, sculpture and painting, his silversmithing benefiting from all of these. Wally is an excellent exponent of using and fostering traditional skills from start to finish on his commissions, inclusive of the all-important drawing and development of ideas.

Fruit bowl by Wally Gilbert.

Vase by Wally Gilbert.

Beakers by Wally Gilbert.

■ DESIGNER-MAKERS

**Memorial bowl by Chris Knight.
(Image courtesy of Adrian Sassoon)**

Chris Knight

Looking at Chris Knight's work it is easy to appreciate and acknowledge that this is a designer with an impressive array of work and thought-provoking ideas. This personal dynamic manifests itself across domestic and ecclesiastical silverware as well as in public art; materials used span from fine metals to steel. Irrespective of the scale, the methods used and the concepts generated, Chris works with technology alongside traditional craft techniques.

This happy marriage of old and new skills has provided Chris with a strong platform from which to make his individual contribution to design, and at the heart of this is the need for him to turn his artistic enquiry into 3D work that is speculative and provokes a reaction from an audience. This draws greater attention to his work as he tests conventions and possibilities of manufacture.

Chris was one of the first silversmiths to venture into the digital age, and computer aided design is fundamental to his

**Coffee set by Chris Knight.
(Image courtesy of Adrian Sassoon)**

DESIGNER-MAKERS

Candelabra by Chris Knight. (Image courtesy of Adrian Sassoon)

larger commissions, but he simply uses this as a contemporary tool and emerging skill to use in the process of designing and producing 3D finished outcomes.

His recent work, where CAD strongly interfaces with traditional crafts, explores different considerations that are exciting and risk-taking. In researching Chris, these outcomes are unsurprising because the bedrock of his skills is fundamental in developing his own style, character and conviction in his work. Collaborative work has also played a key part in his career, along with encouraging fellow silversmiths to be forward thinking and alternative designers.

Chris stands alone in the way he thinks, develops, creates and interacts with his work; he is a great example to others, and firmly promotes the values of craft and technological skills working effectively in harmony. This philosophy is firmly embedded in his teaching and Chris remains a fine ambassador to contemporary and soul-searching design.

Hiroshi Suzuki

There is something especially alluring about Hiroshi Suzuki's work, which sets him apart as an exceptional silversmith and marvellous exponent of traditional techniques in our craft. His work is intuitive; he uses hammering methods and processes so brilliantly, has a unique style and successfully bridges Japanese and European aesthetics. Hiroshi has already made a remarkable and positive contribution to the art and craft of silversmithing.

His designs have every right to be sculpted in clay, but Hiroshi has spent fifteen years in the UK creating vessels that have taken hammering and the sculpting of metal into a different domain, a direct result of committing himself to an excellent foundation of traditional skills-based learning.

Aqua-Posey VII **by Hiroshi Suzuki. (Image courtesy of Adrian Sassoon)**

175

DESIGNER-MAKERS

The vessel forms alone would be challenging enough for most of us to hand raise, but just as important to Hiroshi is the freedom that he provides for himself to create flowing, vigorous and graceful patterns. Again, this treatment to the metal surface is achieved by hammering, chasing and texturing, and close scrutiny of the detail reveals variation and differing effects throughout Hiroshi's portfolio.

This is a rare example in the contemporary world of silversmithing where every part of Hiroshi's designs are formed, nurtured and created by hammering. His skills in sculpting and decorating his vessels have enabled him to design and create uncompromising patterns of fluidity, movement and personal expression. He says, 'I would probably describe my work as ceramics made in silver' – we are fortunate that he opted to work in metal.

Hiroshi now spends half of his time teaching in Japan, so if you want to learn from this master, take yourself to Asia as Wayne Meeten did for two years, to learn the roots of Mokume-Gane. This outstanding example is proof enough that anything is possible as long as you remember and put into practice the origins of the silversmith's craft as you begin to explore, experiment and speculate.

Aqua-Posey XI Kin by Hiroshi Suzuki. (Image courtesy of Adrian Sassoon)

Earth-Reki II by Hiroshi Suzuki. (Image courtesy of Adrian Sassoon)

Jenny Edge

A small number of designer silversmiths specialize in anticlastic raising, a metal forming technique of the silversmith, sculptor and jeweller. In Jenny Edge we have a great exponent of this hammering technique. Her fluid and graceful forms show a strong sense of movement, and often include the clever use of vitreous enamel, promoting two challenging craft techniques that work so well together.

Jenny took herself off to America to learn anticlastic raising from Heikki Seppa, the father of this exclusive technique, and Michael Good, also profiled in this chapter, who is another champion of anticlastic raising. Investing in this level of expertise and guidance was an excellent way to start Jenny off, enabling her to take the technique forward and then create her own brand of work.

Jenny's sculptural forms and sweeping curves reflect her design inspiration and these also provide the opportunity to incorporate her second specialist technique, enamelling. She has broken with tradition by enamelling on the inside of deeply curved surfaces, a difficult technique that takes skill to control and perfect. Here again, Jenny learnt traditional

DESIGNER-MAKERS

Candelabra by Jenny Edge.

Flower vase by Jenny Edge.

techniques from a practising enameller before moving on and exploring her own possibilities.

One contemporary technique that Jenny has learnt and found to be valuable, particularly on her larger, more complex pieces, is TIG welding. She uses this when joining her formed sections together, so this is a good example of hand crafting skills and technology positively supporting and complementing each other.

The combination of Jenny's lightweight forms, reflective qualities in the metal and adornment through the use of vitreous enamel and other chromatic effects, give Jenny's designs a distinctive mark of individuality. This case study reaffirms the value of learning hand making techniques as a bedrock, then searching for something personal and exclusive; it's out there waiting for you!

DESIGNER-MAKERS

'Meteor' bowl by Alex Brogden.

Alex Brogden

Alex Brogden has been designing, making and perfecting his exquisite silverware for almost twenty-five years, and his style, creative interpretation and deployment of specialist techniques have made him a contemporary silversmith of individuality and renown. He has fostered and practised a range of skills through his career but certain areas in particular stand out: his ingenious wax carving, 3D modelling and casting, and the restless progression of his ideas explored through the core techniques of hammering and chasing alongside the process of electroforming. Alex has pioneered

'Axis' vase by Alex Brogden.

Oval wave vase by Alex Brogden.

DESIGNER-MAKERS

a combination of methods, processes and techniques to give his designs detail, presence and stunning visual effects, and his work is unrivalled across the eclectic field of designer silversmiths in the twenty-first century.

Alex's daring patterns provide powerful visual authority and his design interpretation, accurate control and execution defy expectation of what is technically possible through manipulating metal as a medium. These objects demand full attention and repay careful consideration. This is the hallmark of Alex Brogden's designs which, with implausible accuracy and great clarity, exhibit their sculptural connotations with such fluid lines, leaving us intrigued and inspired.

Reflection, illusion and visual intensity evolve from Alex's constant striving for new ideas and his perfecting of hand crafting techniques in conjunction with his pioneering use of electroforming. Unequivocally, this is an example of a contemporary designer working so effectively from and through his ground-breaking exploration and deployment of craft techniques.

Whichever way you wish to analyze his work, Alex is a great stimulus to us all, but particularly to those who are just entering the industry looking for exceptionally inspiring practitioners; in Alex we have just that.

Rod Kelly

Rod Kelly is an exceptional designer-maker with a unique profile: he is a leading silversmith who specializes in low relief chasing, which decorates and adorns much of his design-led work. This aspect alone has given Rod an exclusive style and

Silver dish by Rod Kelly.

DESIGNER-MAKERS

ABOVE: **Low relief chasing by Rod Kelly.**

identity, and for any aspiring silversmith this is an excellent example of an individual pursuing a personal passion and developing his strengths to great effect.

Rod has been fostering his own particular set of specialist skills for over thirty years and within this his sensitive and expressive chasing has become the bedrock and dynamic feature throughout his designs. Rod's artistic, drawing and design talent has also been channelled into other interesting and complementary aspects of silversmithing, such as silver book binding, medals and coins.

This eclectic mix and activity makes him a compelling designer to include in this book and he perfectly illustrates how you can bridge and expand a portfolio through exploiting the core techniques of the silversmith.

Rod works with the traditional techniques of silversmithing, often using hand raising to manufacture his designs. He then applies linear patterns and shallow forms through light relief chasing (an experimental technique that he has spent many years exploring, developing and perfecting) which is further complemented with subtle points of fine gold inlay.

Detail in his linear decoration is very important because everything needs to have a reason and purpose, so Rod spends time, care and attention in creating his designs to

BELOW: **Cruet set by Rod Kelly.**

ensure that his chasing not only decorates with inherent meaning but also enriches his functional silverware. Rod's work is beautifully expressive; these are functional, decorative pieces that are unique and modern. His designs are led by his strength in drawing and being able to capture a design first on paper and then transfer this essence onto silver in the form of low relief decoration.

To conclude, Rod Kelly is a silversmith of international standing who has utilized traditional techniques in his own inimitable way, and this is living proof that you can find your own niche and make a significant contribution to design.

Michael Good

Michael Good, a self-taught jeweller, goldsmith and sculptor has been designing and making his anticlastic creations for over forty years. His portfolio boasts a remarkable contrast in scale from lightweight, refined jewellery to large sculptures. This is a marvellous way to show how a hammering technique can be manipulated and crafted into beautiful art where size has no boundary, proving that confidence, in tune with a craft skill, can result in any object and size of personal expression. Decoration of patination and surface finishes give added value to Michael's designs; they simply increase the intensity of form, movement and contrast in his work.

Double Mobius by Michael Good.

Oval Wave by Michael Good.

DESIGNER-MAKERS

Open Brq Multiple
by Michael Good.

Early on in his career, as with Jenny Edge, also featured in this book, Michael had the good fortune to meet and work with Heikki Seppa, a leading name in the world of metalsmithing. Between them they established anticlastic raising before Michael took this further by inventing/creating the enclosed forms that we see today in this amazing technique, and it was this exciting development that really brought anticlastic raising to the modern day silversmith. This major event and ground-breaking experience gave Michael a foundation on which to build an international reputation for his outstanding use of this forming technique, one that few designers work with, or specialize in.

He continues to teach many people in America and Europe, holding workshops to assist and encourage activity and design exploration through anticlastic raising, so if you wish to learn from an expert, Michael in America and Jenny in the UK are two excellent ambassadors of this exceptional forming technique.

Clearly anticlastic raising is ideally suited to open, free-flowing, organic structures that allow skilled practitioners to form and sculpt metal into ambitious shapes and striking 3D statements. It is also great to be able to use this technique on a variety of metals, whatever size or shape the designer wishes to create. Without question, Michael Good is a champion and great exponent of this specialism, so if you find this forming technique appealing, we encourage you to investigate, learn, explore and enjoy the experience.

Wayne Victor Meeten

Having followed the brilliant work of Wayne Meeten for many years it is easy to understand how and why his designs are very expressive, have deep-rooted meaning and contain cultural values through his personal beliefs. These are all at the forefront of how Wayne thinks, developing his designs into such stunning statements that exude vitality, grace and harmony.

The core hammering techniques alone that Wayne has learnt, developed and mastered require substantial commitment and passion to reach such a great command and control. There is no short cut to attain these skills and mastery on metals and Wayne's somewhat indirect career in silversmithing has enabled him to learn a different mix of hammering techniques. His international perspective has precipitated a wonderful combination of traditional skills that he practises.

This has also been fuelled by a desire to go back to the origins and fundamentals of the craft, and Wayne studied hammering techniques in Japan for two years. His designs

DESIGNER-MAKERS

Hand-raised vessels by Wayne Victor Meeten.

183

are heavily influenced by the movements and philosophy of t'ai chi ch'uan and chi kung, and Wayne particularly exploits the techniques of Mokume-Gane, Shakudo and Shibori – the latter being an alternative to the traditional way of hand raising metal.

Here we see a great example of a designer who passionately channels his philosophy, traditional origins of the craft and eclectic skills into stunning and striking work that goes beyond the simple mastery of the metal. Another lovely twist of identity and individuality is that his design patterns continue on surfaces not normally seen, under the base or inside a vessel for example.

When you view his work or talk to him you can gauge that Wayne is deeply passionate about his philosophy, approach to life, and how much his work means to him. This has evolved from his cosmopolitan and unique career experience, where a basis of fundamental techniques and hammering skills of the metal/silversmith have been centre stage throughout his career.

Alistair McCallum

Alistair McCallum has been at the top of his specialism for many years and has taken the Japanese technique of Mokume-Gane (wood-grain metal) into his own domain by developing and exploring differing ways of working with this demanding technique. This process has been an on-going personal pilgrimage for over thirty years; his passion and driving ambition to create powerful designs have become his distinguishing mark of individuality.

His contact with Mokume started when studying for his Masters; he then took himself off to Japan to seek further knowledge and experience. Initially applying the technique to jewellery, he soon moved onto larger-scale work, which provided sufficient surface area to develop his decorative patterns and identity. The resulting vocabulary in the array of his vessels is proof that this designer has pioneered his own take on Mokume, and has made excellent use of this amazing traditional skill.

Many appreciate, admire and value his work, and Alistair, who has dedicated his career to the technique, is considered a master in this area of specialism. Decorative surface patterns are balanced by simple forms that are spun or hand raised; these craft techniques and generic outcomes enable pattern and form to work in harmony.

Alistair is also able to control the type, arrangement and formation of these chromatic patterns, remarkable when you understand how distorted the metals become when hammering or spinning to take the Mokume sheet into three-dimensional form. The two examples in this book of designers using Mokume-Gane (the other being Wayne Meeten) comfortably demonstrate the difference and diversity that designers can find when using the same traditional technique, to arrive at exciting and different answers.

Mokume-Gane vessel by Alistair McCallum.

DESIGNER-MAKERS

Mokume-Gane vessels by Alistair McCallum.

185

Ide Meabyung by William Lee.

CHAPTER TEN

THE NEXT GENERATION

The pulse, nature and tone of this book have portrayed and exuded an upbeat account of the vibrant activity, culture and life of the practising silversmith in the twenty-first century. It could be argued that there has never been greater evidence of and engagement in the craft of silversmithing than today. An increasing number of designers continue to join the circuit of opportunity to promote and sell their bespoke and individualistic designs. The eclectic range of work that currently exists is breathtakingly wide, and this seems to cater for everyone's taste and appeal. There appears to be no limit to what it is possible for designers to sculpt, fashion and produce, to suit every individual style, desire and requirement.

With the continuing pattern of retraction and decline amongst established silversmithing companies in the UK, Europe and abroad, and the resulting lack of opportunities for university leavers seeking salaried employment in the industry, more and more graduates turn to self-practice soon or immediately after graduating. This guarantees a constant increase in the number of designers wanting to set up as sole traders and although this is probably the toughest route to take – particularly when it comes to generating an income – it remains a popular and attractive option for many people looking for potential success.

Silversmithing as a specialism remains a difficult subject to accommodate and deliver in the university sector but where it exists, it is an important lifeline to help potential designers to grow and foster their passion and interest in the subject; the centres that do offer a viable educational programme remain crucial supporters to aspiring students in silversmithing. The UK remains an enviable operating base for aspiring silversmiths initially to learn, develop, progress and establish a practice in the self-employed community. Evidence of this vibrant and creative culture is far and wide: to confirm this, there are over seventy members in the Contemporary British Silversmiths association and if you visit week one or two of the annual and prestigious Goldsmiths' Fair at Goldsmiths' Hall in London, there are many designer silversmiths exhibiting and promoting their exciting work alongside jewellery designers. In addition, the recently established British Silver Week provides another great opportunity for designers to market and sell their work, and previous promotional events in London, Germany, Brussels and Malaysia provide strong evidence of a desire to market and spread the good work of many talented designers involved in the wonderful craft of silversmithing.

Apprenticeships in the UK do exist but these are small in number and reflect the health and wealth of the established sector of the industry. The continuing and vital support from the Goldsmiths' Company through their indentured apprenticeship scheme keeps this lifeline afloat, making it possible for companies to support indentured apprenticeships within their business. In addition, the outstanding and recently opened Goldsmiths' Centre in London will also be a great supporter of high-quality training in designing and making silver, jewellery and goldsmithing work. It is a great resource and centre of excellence for many people to use, share, network, demonstrate and learn from. In short, this Centre is a mecca that engenders good practice, encouraging and promoting excellence as it attracts top quality professionals to impart individual skills and craftsmanship, both old and new, to reciprocal learners.

Bishopsland Educational Trust in Oxford and the Starter Studio Programme in Sheffield are again excellent centres for fostering some of the next generation of silversmiths. It is hoped that more of these organizations will emerge and add to the opportunities for people wanting to commit themselves to silversmithing and are serious about making the subject a future career.

■ THE NEXT GENERATION

We have no doubt in our minds that much talent exists and emerges each year from university courses and training systems alike; the information above demonstrates that there are positive avenues to explore, to take individual interests and skills further and longer into the future. Evidence shows that a good percentage of these do take the next step and start on the road of self-employment.

This all paints a very healthy level of activity and support for the collective gain of the craft and its industry, but it is so critically important to retain, promote and exercise the core activities of silversmithing as early learners become interested and engage in the subject. This book, first and foremost, is a teaching journal and contemporary guide to assist interested parties to exercise and learn the core skills of traditional silversmithing techniques. We urge all candidates to use this book as a foundation of skills-based learning, and encourage you to always remember and work from these principles. Continue to use, retain and promote the traditional values and correct methods, techniques and processes because this will keep you on the right track and enable you to produce high quality work, whatever situations you encounter.

At present we are confident that a good number of craftsmen and craftswomen currently operating as silversmiths demonstrate standards of excellence through their work. With continued or increased support, individual strengths, skills and standards will continue to foster, develop and enhance the quality of craftsmanship.

The collective gain is obvious and thereby serves the health and wealth of silversmithing, as we all seek its continued success and prosperity. Another crucial factor running alongside designing and making are the ever-important aspects of marketing, promoting and selling. It doesn't necessarily follow that you will find it easy to do these things successfully. Over a career of creating, designing and making a business, it can only continue to operate if its work is seen and bought by potential customers – people who appreciate good work and actually support it by purchasing design-led pieces.

In this chapter is a small sample of young designer silversmiths with their chosen specialist techniques. They are doing their own highly individual work, each demonstrating talent, creativity and potential for a rewarding career and lifelong experience in silversmithing. These designers are doing what they believe in and producing some high-quality silverware for public attention and consumption. This brief but striking straw poll of the future should be sufficient to demonstrate we are confident and heartened that the next generation will promote, protect and enhance the traditional craft of silversmithing in a contemporary domain.

Sang-Hyeob 'William' Lee

William Lee is a designer-maker who is following hot on the heels of his seniors with his skills, ability and designs; he has already generated a remarkable array of hand-hammered vessels. His work is all about utilizing and promoting the traditional hammering skills and techniques of the silversmith, and he is a confident and competent craftsman. After our consultation session with William and hearing about his education and training we could see how he has managed to become a great prospect for the future. This is an excellent reminder that there is no substitute to learning from experienced craftsmen. Putting yourself in the company of such people for sustained periods will enable you to absorb, learn and allow

Gold Hori mini hand-raised vessel by Sang-Hyeob 'William' Lee.

THE NEXT GENERATION

their core skills to work through you over time, with plenty of patience and application.

When in his native Korea, William studied and worked under a master metalworker/artist/silversmith. This demanding three-year period gave William a traditional anchor, priceless experience and a valuable learning curve. His move to the UK to learn English, study sculpture and progress to a degree course enabled him to extend his connections and learning, as he undertook work experience with masters, most notably Hiroshi Suzuki and sculptor Anthony Gormley. Winning the Young Designer Silversmith Award in 2003 as a student gave him excellent exposure, enhanced his network of contacts and designers and also directly led to liaising and working with silversmith Richard Fox. There are more instances to quote but already this account shows a logical, cohesive and valuable route to becoming a skilled and experienced craftsman.

William continues to work in the UK and this profile serves as an excellent case study: he has accrued a super range of experiences and learning, coming into contact with important and high profile people en route. He has already gained the respect and admiration of designer-makers for his skills, what he can create and how he exercises the traditional techniques of silversmithing. This perfectly illustrates what is possible, and endorses the fact that success is out there if you have the ambition and determination to go for it. William has also produced a very helpful YouTube clip about raising – a very good teaching and learning aid.

Distorted Hori – hand-raised vessel by Sang-Hyeob 'William' Lee.

Moor Vase – hand-raised vessel by Sang-Hyeob 'William' Lee.

Miriam Hanid

Young and talented, Miriam Hanid is an exceptional artist silversmith who has established her own style, identity and unique position within the population of contemporary designer silversmiths. She combines her passion and affinity with nature into expressive statements in silver designs that exquisitely capture the essence of her inspiration.

Miriam combines the traditional techniques of chasing, repoussé and hand engraving, and uses these to good effect across her work, proving that if you assign yourself to specific craft techniques, work them hard and feature them within your work, you can begin to turn them to your own manner, style and advantage.

These specialist techniques work so well together: the chasing and repoussé work provides definition, artistic

THE NEXT GENERATION

'Coriolis' centerpiece by Miriam Hanid.

'Transformation' vase by Miriam Hanid.

expression and bold authority, with the additional benefit of creating structural strength from the chasing and hammering throughout the vessels. Miriam's hand engraving offers a complementary contrast that helps to depict and confirm the free-flowing organic ethos of her designs.

As part of the next generation, Miriam is a fine ambassador for these specialist aspects of the craft – a super endorsement to aspiring silversmiths that finding an attraction to specific craft techniques, and developing and exploiting them to good effect, will provide a redoubtable foundation for doing your own thing and creating a name for yourself as a designer-maker of note. This all links with the primary aim of this book: to promote and instil the importance of learning the core skills of silversmithing.

From this profile it is safe to conclude that the future looks bright for the continuation and prosperity of the traditional techniques and skills of the silversmith, and in this instance they are in harmony with one of their natural partners, contemporary design.

THE NEXT GENERATION

Whirlpool bowl by Miriam Hanid.

Rebecca Joselyn

We were particularly keen to include Rebecca Joselyn in our book. Her work is unmistakable, interactive and, in its own way, exclusive. Rebecca's fashionable take on crafting everyday items into symbolic silver tableware demonstrates a particular set of skills and craftsmanship.

Milk jug by Rebecca Joselyn.

Condiment pot by Rebecca Joselyn.

191

Packet vases by Rebecca Joselyn.

On the surface it might seem a relatively simple and straightforward task to manufacture these iconic products to good effect, but this belies the skills, control and aesthetic interpretation that you need to attain. You simply cannot achieve this without a good understanding and relationship with metal, a sound command of hand making craft techniques and sensitive translation of these types of artefacts.

This comfortably validates and supports any designer-maker who seeks to develop a personal expression and particular style using craft skills and techniques really well, where the hand making skills are fundamental to the successful fabrication and translation of the work. There are very few designers who either wish, or are able, to capture this style of work as exhibited here.

Esther Lord

In direct contrast to hand raising techniques, Esther Lord employs a different combination of workshop process in her work. Esther's clean, crisp and contemporary designs are further complemented with refined, subtle finishes and surface treatment.

These techniques and processes rely heavily on neat and accurate making; there are no corners in which to hide, since poor standards of construction would be easily exposed and immediately apparent. Scoring, bending and folding techniques are inherent processes in this example, and the finishing processes in this instance are of critical importance.

For this type of surface treatment, neat, fastidious and careful finishing is paramount. Satin, directional and textured surfaces play a crucial role in the visual impact and effectiveness of a design.

For any type of finishing there is no difference in the amount of work, care and attention that must be invested in

THE NEXT GENERATION

Fruit bowl by Esther Lord.

Condiments by Esther Lord.

Jewellery boxes by Esther Lord.

193

THE NEXT GENERATION

the final stages prior to polishing. This is all-important and in fact some would argue that for satin, butler and directional finishes the quality of the preparation work has to be higher than for a high lustre, polished finish.

Kevin Grey

Kevin Grey's designs are simplicity personified: his shapes, forms and refined detail combine in exceptional and ingenious ways.

As noted in Chapter 7, Kevin's background offers some explanation as to why and how he is able to produce this consummate style of decorative work, which requires a particular set of technical skills and abilities. His previous trade in the luxury motor industry provided a foundation of hand

Sinew Vase by Kevin Grey.

Sinew Vessel by Kevin Grey.

Bowl by Kevin Grey.

fabrication skills along with technological and production processes, and specifically laser and TIG welding. These skills, combined with siversmithing, have given Kevin the opportunity to extend his designs beyond the realms of what is traditionally perceived as silverware.

His generic forms are created by bringing a series of hand-cut strips together and joining them by laser and TIG welding. If you are familiar with this alternative method of joining silver you will immediately appreciate the skills that are needed to perfect this technique and application – they are difficult to master.

The simple forms host complicated techniques, requiring accuracy, control and a confident command throughout their fabrication. Of course, when demonstrated by a master craftsman it all looks easy. Kevin enjoys these technical challenges and takes an intuitive approach to stretching, shaping and joining metal precisely. His contemporary skills are different from those of the traditional silversmith but many senior craftsmen respect and admire this type of work and level of technical competence.

His designs successfully demonstrate how tradition and technology can work well and in harmony. So the morals here are clear and simple – traditional skills can be acquired and utilized in a variety of ways, and from different industries that can enable an individual to develop and pioneer exceptional and exclusive work; Kevin Grey is living proof of this.

Chased bowl by Zoe Watts.

Zoe Watts

Zoe Watts has already found a strong connection and natural affinity with chasing and repoussé, and is beginning to make a positive impression as a designer-maker. The unadulterated core techniques of chasing are at the heart of this exciting development and activity, and Zoe is boldly expressing her design ambitions into this exceptional allied craft of silversmithing.

This age-old and somewhat laborious technique is practised by relatively few in the modern era, and the number of designers who use it as a mainstream activity in their silverware designs is even smaller. Remarkably, the tools, materials and techniques have remained relatively unchanged down the centuries. There seems no quick fix or easy way to become skilled and articulate in manipulating and moving metal into forms, shapes and patterns; great care, attention and patient application are required.

The adage that there is no substitute for hands-on experience certainly holds true in this instance, but within the next generation of designers there are a few who are showing the necessary aptitude, desire and ability to demonstrate that you can adopt this ancient tradition and work it to your advantage. Zoe is doing just that but it is also important to note that (as with a good engraver and modeller) you need to work hard on your artistic abilities and understanding of form, movement and detail, and learn to translate your designs sensitively from drawings onto metal.

So this is where the classical and the contemporary can meet to form a dynamic partnership. Here art, design and craft skills are being exercised, promoted and celebrated, both independently and in unison. Early on in her career a young Zoe Watts has locked onto this specialist and unique aspect of silversmithing, and is a fine advocate for promoting the traditions of chasing in the twenty-first century.

■ THE NEXT GENERATION

Chased bowls by Zoe Watts.

Angela Cork

Following on from our technical descriptions of scoring and folding, Angela Cork is an excellent exponent of these techniques, demonstrating how these skills can be mastered and directed to give a positive return in your work. If you research Angela you will see that this control and quality is ever-present in her pristine and contemporary silver designs.

Accuracy, neatness and meticulous attention to detail sit seamlessly within these specific techniques, and these demands are unforgiving if you fall below such exacting standards. It may seem an obvious statement, but you need to become a good practitioner in scoring and folding if you wish to exploit these particular traditional hand making techniques.

One of the crucial factors here is that there is no substitute or alternative for making this type of construction work to very high standards. Your work will display great visual qualities if you can craft it beautifully, and we can't emphasize this enough; the reward is exemplified in the work of this designer.

Silver vases by Angela Cork.

Frame vase by Angela Cork.

Pivot fruit dish by Angela Cork.

FURTHER INFORMATION

ORGANIZATIONS

The Goldsmiths' Company – www.thegoldsmiths.co.uk
The Goldsmiths' Centre – www.goldsmiths-centre.org
The Goldsmiths' Craft & Design Council – www.craftanddesigncouncil.org.uk
The Contemporary British Silversmiths – www.contemporarybritishsilversmiths.org
British Silver Week – www.britishsilverweek.co.uk
Festival of Silver – www.britishsilverweek.co.uk
The Hammer Club – Forum for professional silversmiths – www.silberschmiede-forum.eu/
The Silver Trust – www.silvertrust.co.uk
The World Gold Council – www.gold.org
The Institute of Professional Goldsmiths – www.ipgoldsmiths.com
The Hand Engravers Association – www.handengravers.co.uk
The National Association of Goldsmiths – www.jewellers-online.org
Qest – Queen Elizabeth Scholarship Trust – www.qest.org
The Crafts Council – www.craftscouncil.org.uk
The National Heritage Crafts Association – www.heritagecrafts.org.uk
The Society of Designer Craftsmen – www.societyofdesignercraftsmen.org.uk
Chartered Society of Designers – www.csd.org.uk
The Design Trust – www.thedesigntrust.co.uk/craft-new-trade-show/

TRADE FAIRS

UK/Europe

Goldsmiths' Fair, London – www.thegoldsmiths.co.uk/exhibitions-promotions/goldsmiths'-fair
International Jewellery London – www.jewellerylondon.com
NEC Spring & Autumn Fairs – Birmingham – www.thejewelleryshow.com
Baselworld – Basle, Switzerland – www.baselworld.com
EPHJ-EPMT-SMT – Geneva, Switzerland – www.ephj.ch/w3p/en/2570
Inhorgenta – Munich, Germany – www.inhorgenta.com
Vicenza Oro –Vicenza,Italy – www.vicenzajewellery.com
Midora – Leipzig, Germany – www.leipziger-messe.de

International

JCK Las Vegas Show – America – www.lasvegasjckonline.com
Hong Kong International Jewellery Show – www.hkdc.com/fairhkjewellery-en
CWJF – China Watch Jewellery & Gift Fair – Shenzen, China – www.chinaexhibition.com
IJF - JAA International Jewellery Fair – Sydney – www.jewelleryfair.com.au

MAGAZINES AND JOURNALS

UK

Crafts – www.craftscouncil.org.uk/crafts-magazine
Craft & Design Magazine – www.craftanddesign.net
The Goldsmiths' Company Technical Journal – www.thegoldsmiths.co.uk/training/technical/technical-journal
The Goldsmiths' Company Review – www.thegoldsmiths.co.uk/review
The Bench – www.cooksonmagazine.com

Overseas

American Crafts – www.americancrafts.com
MJSA Journal – www.mjsa.org
Metalsmith – www.snagmetalsmith.org

FURTHER INFORMATION

Goldschmiede Zeitung –
 www.gz-journal.de
Art Aurea magazine – www.artaurea.com

Ejournals

Benchpeg – www.benchpeg.com
The Ganoskin Project –
 www.ganoskin.com
The Design Factory –
 www.thedesignfactory.co.uk
The Design Trust newsletter –
 www.thedesigntrust.co.uk
Cockpit Arts Designer-Maker newsletter
 – www.cockpitarts.wordpress.com

COMPETITIONS

UK

The Goldsmiths' Company Young
 Designer Silversmith –
 www.thegoldsmiths.co.uk/news
The Goldsmiths' Company Precious
 Metals Bursary Scheme –
 www.goldsmiths-institute.org
The Goldsmiths' Craft & Design Council
 – www.craftanddesigncouncil.org.uk
The Jerwood Prize – www.jerwood.org
The Belvanie Masters of Craft –
 mastersofcraft.thebalvenie.com

International

Silber Triennale International –
 www.klim02.net/awards/gfg-silver-
 triennial-2013

CAREER PROGRESSION

Teaching centres

The Goldsmiths' Institute, London –
 www.thegoldsmiths-centre.org/
 institute
Holts Academy of Jewellery –
 www.holtsacdamey.com
Edward Mahony – Faversham –
 E.edwardmahony@hotmail.com

Post graduate centres

Yorkshire Art Space, Sheffield –
 www.artspace.org.uk
Bishopsland, Oxford –
 www.bishopsland.co.uk

Workshop communities

Cockpit Arts, London –
 www.cockpitarts.com
Craft Central, London –
 www.craftcentral.co.uk
Yorkshire Art Space, Sheffield –
 www.artspace.org.uk
Design Space in Birmingham – www.
 birmingham.gov.uk/design-space

ASSAY OFFICES

The Goldsmiths' Company Assay Office
Telephone: 020 7606 8971.
www.assayofficelondon.co.uk
Birmingham Assay Office
Telephone: 0871 871 6020.
www.theassayoffice.co.uk
Sheffield Assay Office
Telephone: 0114 231 2121.
www.assayoffice.co.uk
Edinburgh Assay Office
Telephone: 0131 556 1144.
www.assayofficescotland.co.uk

HEALTH AND SAFETY ISSUES

Competent Persons Register –
 www.competentperson.co.uk
Gas Safe Register –
 www.gassaferegister.co.uk
Government legislation –
 www.legislation.gov.uk
The Health and Safety Executive –
 www.hsemail:gov.uk
National Association of Professional
 Inspectors and Testers –
 www.napit.org.uk

SUPPLIERS

Precious Metal and Refiners – UK

Arjex
www.argex.co.uk
Baird & Co
www.goldlinemail:co.uk
Ballou Findings International
www.ballou.com
Bellore
www.bellore.co.uk
Birmingham Metal (gold, platinum & palladium mesh)
www.birminghammetal.co.uk
Cooksongold
www.cooksongold.com
Euro Mounts & Findings LLP
www.eurofindings.com
www.euromounts.com
European Precious Metals Federation
www.epmf.be
Landale Ltd
www.landalemetals.co.uk
Metalor
www.metalor.com
PGR
www.plusgold.com
Rashbel UK Ltd
www.rashbel.com

FURTHER INFORMATION

Stephen Betts & Sons
www.bettsmetals.com
Thessco
www.thessco.co.uk
Tony Jarvis
Telephone: 0207 491 2032

Precious Metal Suppliers and Refiners – International

Metalor USA Refining Corporation, 255 John L. Dietsch Boulevard, North Attleboro, MA 02763, USA
Euro Mounts & Findings LLP – Australia
www.euromounts.com
C. Hafner Gmbh + Co. Kg, Gold and Silver Refinery, www.c-hafner.de

Base Metals

Brookside Metal Company
www.brooksidemetal.com
Cuxton Metals Ltd (Cml Trading)
www.cuxtonmetals.co.uk
John Keatley (Metals) Ltd
www.johnkeatleymetals.com
M.G. Supplies
www.mgsupplies.com
Rudgwick Metals Ltd
www.rudgwickmetals.co.uk
The Scientific Wire Company
www.scientificwire.com
Smith Metals Centre
www.smithmetal.com
K. Smith & Co (Stainless Steel Wire)
Telephone: 01600 713 227
Speciality Metals
www.smetals.co.uk
Ultimet Group
www.ultimetalloys.com

Tool Suppliers in the UK

Bellore (see under Precious Metals)
Cooksongold (see under Precious Metals)
Le Ronka Ltd
www.leronka.co.uk
Rashbel Uk Ltd (see under Precious Metals)
Sutton Tools
www.suttontools.co.uk
H.S. Walsh & Sons
www.hswalsh.com

Tool Suppliers Elsewhere

Rio Grande, USA
www.riogrande.com
Fischer Edelstahlrohre Gmbh, Germany
www.fischer-group.com

Materials

4d Modelshop Ltd (a wide variety of materials)
www.modelshop.co.uk
Allstyle Products
www.allstyleproducts.co.uk
Alma Leather
www.alma1938.com
Berry & Son (leather and skin suppliers)
www.tonbridge.opendi.co.uk
Blue Crystal Glass
www.bluecrystalglass.co.uk
E Magnets UK
www.e-magnets.com
Hamar (acrylic supplies and fabrication)
www.hamaracrylic.co.uk
K & M Wholesale Suppliers Ltd (perspex sheet)
www.192.com
H. Shaw Magnets Ltd
www.shawmagnets.com
Pentonville Rubber
www.pentonvillerubber.co.uk
Tempo Leather Group Ltd
www.leatherbuyersguide.info
Timberline (tropical hardwoods)
www.exotichardwoods.co.uk

Gemstones

Henig Diamonds
www.henigdiamonds.co.uk
Holts
www.holtsgems.com
R.M. Weare & Company Ltd
www.richardweare.co.uk
Marcia Lanyon
www.marcialanyon.co.uk

SERVICES & COMMODITIES

Spinners

David Allison
Telephone: 07808 171 691
Email: silver-spinner@hotmail.com
Stephan Coe
Telephone: 01276 857 799
John Need
Telephone: 07934 608 040
Email: johnneed@hotmail.com
Stuart Ray
Email: stuart.ray1@googlemail.com

Stamping

Abbotts Stampings
Telephone: 0121 456 4900

Chasers

Gavin O'Leary
Telephone: 01732 874 396
Rodney Smart
Telephone: 01483 827 919
Email: rodbmsmart@hotmail.com

Modellers

Julian Cross
www.juliancross.com
Lexi Dick
Email: info@lexidickjeweller.co.uk
Simon Dyer
Telephone: 07767 372 172
www.simondyerart.com
Robert Elderton
Telephone: 0203 004 9806
www.ipgoldsmiths.com
Mark Gartrell
Telephone: 0208 540 3988
Email: gartrell@btinternet.com
Gavin Haselup
Telephone: 0203 004 9806
www.ipgoldsmiths.com
Lakeland & Mouldings (resin moulds & castings)
Telephone: 01768 486 989
www.lakelandmouldings.co.uk
Timothy Lukes
Telephone: 01736 798 753
www.timothylukes.co.uk
Roddy Young
www.clancrestsilver.com

Engravers

The Hand Engravers Association
Telephone: 0750 046 2910
www.handengravers.co.uk
David Bedford – J.J. Bergin Ltd
Telephone: 0207 833 3333
Email: bergindrome@yahoo.co.uk
Sam James Engraving
Telephone: 0207 253 0692
www.samjamesltd.com
Dexter – Seal Engraving
Telephone: 01580 240 993
www.familysealrings.com
Malcolm Long Ltd
Telephone: 01765 640 301
www.malcolmlong.com
Steve Munro
Telephone: 07797 725 281
Email: imperial@jerseymail.co.uk

Wayne Parrott
Telephone: 0208 458 1731
R.H.Wilkins (Engravers) Limited
Telephone: 0207 405 5187
www.rhwilkins.co.uk

Enamellers

Ruth Ball
Telephone: 01704 577 585
http://ruthball.weebly.com
Phil Barnes
Telephone: 01728 668 123
Kempson & Mauger Ltd
Telephone: 01277 824 754
Keith Seldon – Artist Enameller
Telephone: 01883 344 456
www.keithseldon.co.uk

Enamelling Suppliers

Vitrium Signum – Enamelling Equipment & Supplies
Telephone: 0208 524 9546
www.vitriumsignum.com

Resin Enameller

Stainslav Reymer
Telephone: 0208 543 6821
www.sreymer.co.uk

Technology

Wire Erosion
R. F. Bevan & Co Ltd
Telephone: 0121 236 9263
www.rfbevan.co.uk

LASER CUTTING
Jewellery Industry Innovation Centre
Telephone: 0121 331 5940
www.jewellery-innovation.co.uk

LASER WELDING
Anne-Marie Carey
Telephone: 0121 248 4579
Email: ann-marie.carey@bcu.ac.uk
Kevin Grey
Telephone: 07933 302 557
www.kevingrey.co.uk

WATER JET CUTTING
Aquacut Ltd
Telephone: 01565 750 666
www.aquacut.co.uk
SCISS
Telephone: 01580 890 582
www.sciss.co.uk

COMPUTER AIDED DESIGN
Cad Man
Telephone: 0207 608 0058
www.cad-man.co.uk
Folkstone Precision
Telephone: 01303 255 465
Richard Gamester
Telephone: 07825 661 028
Email: design@richardgamester.com
Jack Meyer
Telephone: 0207 405 0197
www.holtsacademy.com
Simon Ottaway
Email: simonottaway@uk2.net

ELECTROFORMING
BJS Company Ltd
Telephone: 0208 810 5779
www.bjsco.com
Fox Silver Ltd
Telephone: 0208 683 3331
www.foxsilver.net

Polishers & Platers

Butterworths Regalia Ltd
Telephone: 01843 592 475
Cheyne & Close Ltd
www.silverpolishing.co.uk

FURTHER INFORMATION

Elliot & Fitzpatrick
Telephone: 0207 404 5124
Email: elliotfitzpatrick@aol.com
Steve Goldsmith
Telephone: 07976 898 985
www.smgkentltd.com
Trevor Goodfellow
Telephone: 07958 616 176
F. Sinclair Ltd
Telephone: 0207 404 3352
www.fsinclairltd.co.uk

Casting

AA Fine Castings Ltd
Telephone: 0207 700 5900
www.aafinecastings.co.uk
ABT Design
Telephone: 01474 324 428
www.abtdesign.co.uk
BAC
Telephone: 0207 253 3856
www.clerkenwell-silver.co.uk
Barrett & Jarvis
Telephone: 01580 893 500
www.barrettandjarvis.co.uk
Domino
Telephone: 0121 236 4772/0207 430 2914
www.dominojewellery.com
Euro-Cast – Merrell Castings
Telephone: 0121 236 3767
www.euro-cast.co.uk
West 1 Castings
Telephone: 0207 831 8542
Weston Beamor
Telephone: 0121 678 4131
www.westonbeamor.co.uk

Engineering

2D Engineering Ltd (silver machining)
Telephone: 01233 820080
www.2d-engineering.com

Machinery

Home & Workshop Machinery
Telephone: 0208 300 9070
www.homeandworkshop.co.uk
Lathes.co.uk
Telephone: 01298 871 633
www.lathes.co.uk

Etching

Chempix
Telephone: 0121 380 0100
www.chempix.com

Setters

Martin Beresford
Telephone: 01233 622 362
Steve Copas
Telephone: 07814 394 076
Email: stevencopas@hotmail.co.uk
Niall Paisley
Telephone: 07742 393 106
Email: niallpaisley@gmail.com
Ian Reed Setting Ltd
Telephone: 01892 722 331

Presentation Boxes & Packaging

Jewel Display Ltd
Telephone: 01842 814 722
www.jeweldisplay.com
Macfarlane Packaging (packing film)
Telephone: 0800 288 8822
www.macfarlanepackaging.com
Pollards International
Telephone: 0151 526 3456
www.pollardsinternational.com
Potters
Telephone: 01553 780 850
www.pottersuk.com
Wheeler & Oliver
Telephone: 02392 580 183
www.wheelerandoliver.com

Photographers

Simon B. Armitt
Telephone: 07880 948 095
www.simonbarmit.com
Bill Burnett
Telephone: 0207 242 7031
www.billburnett.co.uk
Keith Leighton Photography
Telephone: 07799 661 207
www.klphotography.co.uk
Lee Robinson
Telephone: 07760 453 664
www.leejorobinson.com
Richard Valencia
Telephone: 07768 315 309
www.rv-photography.com

GLOSSARY

3D laser cutting: laser cutting equipment capable of cutting around and over a three-dimensional shape.

Alloyed: a metal made by combining two or more metallic elements, e.g. sterling silver is 925 parts pure silver and 75 parts base metals. This gives greater strength and resistance to wear and corrosion.

Anti-clastic raising: a technique of metal forming where sheet metal is hammered on a sinusoidal (snake-like) stake. The metal is shaped by compressing its edges and stretching the centre so that the surface develops two curves at right angles to each other.

Anvils: a very heavy steel or iron block with a flat top, concave sides, and typically a pointed end, on which metal can be hammered, forged and shaped. Traditionally, the anvil was the blacksmith's fundamental tool and workhorse.

Argotect: a deoxidizing flux that provides sterling silver with protection against fire stain. In powder form it is mixed with methylated spirit to a paste consistency and applied over the surface area of silver to be annealed or soldered.

Basse-taille: a technique in which transparent or translucent enamel is fused over an engraved or carved metal background. This gives a play of light and shade over a low cut design as well as a brilliance of tone.

Binding: word or term associated with temporarily bringing components together to be soldered. This is done using iron binding wire to position, tighten and hold units together throughout soldering. Care needs to be taken that solder doesn't run onto or along binding wire and all wire must be removed before placing your work in the cleaning solution.

Bullion: traditionally means gold, silver and other precious metal bars or ingots. More recently the term 'bullion' has also been used to describe tradable ingots or bars of base metals such as copper, nickel and aluminium.

Bullion suppliers: companies who refine, produce and retail precious metals.

Burr free: a term used for metal surfaces without residue or waste material from a process such as photo mechanical etching, drilling, laser and water jet cutting. Any burred edges usually need to be removed by filing and/or sanding.

Butler and directional finishes: alternative surface finishes to a high polish. Preparation for butler and directional finishes is exactly the same as a high lustre polish. Whitening powder is brushed on to convert the finish from polish to a sheen/lustre and directional finish is by using a scotch bright mop or a more abrasive material to achieve lines/directional finish. Both finishes can contrast with a high polish or be applied throughout a design.

CAD: computer-aided design

Champlevé: enamelling technique in which cells or troughs are carved to enable vitreous enamel to be filled and fired into these depressions.

Cloisonné: ribbons of wire soldered onto a base to form cells that are filled with ground enamel, then placed in a kiln for firing and fusing.

Coat of arms: a unique heraldic design on a shield, escutcheon, surcoat or tabard. A coat of arms is used to cover, protect and identify the wearer.

Cold cure mould: a liquid silicon rubber compound for pouring into master pattern moulds that cures to a solid form and creates an perfect impression of a master pattern. A direct alternative to vulcanising rubber where pressure and high temperatures melt the rubber, again forming an exact fit around a master pattern.

Computer aided manufacture: precise and accurate milling/cutting on metal and wax by means of computer software to control machine tools and related machinery in manufacturing.

Computer numerically controlled: controlled, precise cutting on a milling machine where all cutting actions are programmed from a CAD file.

Conch shells: the common name applied to a number of different medium to large-sized sea snails or their shells.

Convention hallmark: an alternative to traditional hallmarks, articles may be marked with a convention hallmark which

GLOSSARY

may have been applied by any country that is part of the international convention on hallmarking.

Cotter/split pins: Steel pins used for holding and supporting silver components in preparation for soldering.

Crank: the neck or loose 's' type bend in cutlery, particularly on spoons. The section interchange between the handle and the working end of cutlery, e.g. between the handle and bowl of a spoon.

Crucible: a ceramic container for melting precious metals, mainly for casting or pouring into ingot moulds. Crucibles can be made from any material that withstands temperatures without mixing with the molten metal.

Cupel: a shallow, porous container, often made of bone ash in which gold or silver can be refined or assayed to separate precious metals from base metal alloys.

Cut card: pierced or laser cut patterns on metal that usually slide over or fit onto the main shape of a vessel or sleeve etc.

Dies: hard steel plates with patterned holes for drawing wire through to progressively shape metal into an intended section and form.

Digital hammering: a new technological technique developed by Kathryn Hinton. This form is created on computer from a flat digital mesh where points are formed into a bowl shape using Kathryn's own digital hammering technique.

Ductile joints: refers to the value of using easy silver solder that provides less brittle joints from using a lower melting point solder.

Electroforming: is a repetitive forming process by the deposition of pure metals onto a pattern, former or mandrel. Quite different from electro plating that deposits pure metals onto a finished object, electroforming forms thin layers to create a thickness and skin over the mandrel that can be removed to leave a pure metal replica of the master. Depending on the thickness, this can exist as a self-supporting structure. The thicker the deposit of pure metal, the more expensive it becomes.

Electro plating: the deposition of fine silver or gold through anodes, chemical solution and electrical current by a strike transfer onto the silver surfaces of the product. The longer the plating time, the greater the micron deposit harder wearing surface, but equally, the higher the cost of the electro plating service.

Embosser: a process of creating a three dimensional image or pattern by using metal dies to press form into metal by stamping.

Engine turning: a hand operated machine that makes accurate and controlled bright cuts onto metal surfaces, creating symmetrical patterns and shapes as a striking decorative effect. Cigarette cases, pill boxes, lipstick containers, compact cases, ladies accessories, etc. are typical products where engine turning is employed.

Epergne: a type of table centrepiece and generally has a central bowl or basket sitting on three to five feet. Branches radiate from this supporting small baskets, dishes or candleholders. A traditional use of an epergne was to display side dishes, fruit or sweetmeats.

Extraction: the removal of dust, smoke and chemical fumes from the workshop environment, by means of air suction and extraction. Extraction is a Health and Safety regulation.

Finial: a decorative and ornamental aspect within a design. This is employed to emphasize detailed areas at the top, end or corner of a design and usually has a repetitive pattern.

Firestain and firescale: a red or purple staining created from one or a number of heating applications on silver. It is the formation of copper oxide on or near the surface of the metal. Higher temperatures and the number of heating applications will determine the depth and amount of firestain/firescale present.

Flux: common term for the range of fluxes/cleaning agents available on the market for soldering. Borax, Auflux, Tenacity, Easy-Flo are the main branded fluxes available.

Frieze: ornamental decorative patterns and repetitive detail that are usually in one direction. These edge or fringe some traditional silverware, e.g. the frieze of grapevines that decorate the Wine Cooler in Chapter 1.

Gadrooned: an ornamental silver band, embellished with fluting, reeding, beading or other continuous patterns.

Gold inlay: recessing gold sheet, wire or tube into silver or other precious metals. The traditional method involves carving a recess into the sheet to receive gold inlay, which is then hammered into position. Other techniques include etching, piercing and rolling. Soldering is also used as an alternative to the traditional method.

Huguenot: members of the Protestant Reformed Church of France who relocated to many countries (including the UK) in the sixteenth and seventeenth centuries.

Hydraulic forming: the use of liquid pressure to mould metals by means of fluid hydraulic pressure that actuates the ram/force required when forming. It is the same manner and procedure when using a fly press by hand without the action and physical effort.

Kuromido: an alloy of 99 per cent copper and 1 per cent metallic arsenic. It is most commonly used as one of the metals associated with Mokume-Game.

Laser scintering: technological process to form 3D objects by a high powered laser that fuses small metal particles into a mass that is an exact representation of a design on computer.

Laser welding: uses a laser beam to weld metals together. The laser provides a concentrated heat source that allows deep welds and high welding rates.

Lead cake: as a very soft metal, a block or cake of lead is used for hammering and stamping metal shapes into. This

needs regularly smelting or melting after moderate use to re-establish its block form again for further hammering to be continued and effective.

Linish: to strip/remove metal, wood and other materials with emery, or other abrasive clothes by mechanical means i.e. a linishing machine with a rotating emery belt.

Lion passant: lion is the common charge in heraldry, symbolizing bravery, strength and royalty. The Lion Passant is the traditional fineness hallmark mark for sterling silver.

Lost wax casting: the process by which a metal can be cast from a master pattern into a mould or flask. Replica wax patterns created from the master are burnt out from a plaster flask to enable molten metal to be forced into the flask to create multiple metal patterns of the master.

MDF: Medium Density Fibreboard is an engineered wood product formed by breaking down hard and soft wood residuals into wooden fibres, in combination with wax and a resin binder.

Milliput: a two part, cold setting, non-shrinking epoxy putty used for 3D modelling and sculpting. Milliput can be used as a repair agent on a wide range of materials, including metal.

Mokume Game: sometimes spelt Mokume-Gane, this is a mixed metal laminate with distinctive layered patterns. Traditional components are soft metallic elements and alloys (gold, copper, silver, shakudo, schibuichi and kuromido) which would form liquid phase diffusion bonds with one another without completely melting. Contemporary advances on the technique has enabled the use of non-traditional components such as titanium, platinum, iron, bronze, brass, nickel silver and various carat golds as well as sterling silver.

Neo-Classical: a late eighteenth- and early nineteenth-century style in architecture, decorative and fine art, based on the imitation of surviving classical models and types.

Ninevah: an ancient city located on the eastern bank of the Tigris river, opposite the modern city of Mosul, Iraq.

Nitric acid erosion process: nitric acid used to etch silver and base metals, mainly for decorative purposes to create surface patterns that offer decoration and opportunities to use colour contrast for visual impact and effect.

Pallions: small squares, rectangles and other cut shapes of solder normally applied to a joint for tacking or soldering, with a fluxed brush. Depending on the volume of area to be soldered, this is an alternative method compared to the favoured application of stick feeding solder to a joint etc.

Pantograph: a machine that can duplicate writing, patterns and detail at larger sizes from a master pattern. Used mainly for engraving by means of a mechanical linkage connected in a manner based on parallelograms, following a master pattern provides an identical and larger replication of the master pattern.

Patination: a tarnish that forms by oxidation or chemical process, on metals such as copper, bronze and similar materials. This can occur naturally when metals are exposed to atmospheric elements or by applying chemically induced compounds such as oxides, carbonates, sulphides or sulphates.

Photo chemical etching: accurate acid etching process using camera facilities and CAD data manipulation along with photo tool technology for ultimate precision.

Pickled: term used for immersing your work in an acid based solution for cleaning oxides and borax after annealing and soldering.

Pierced: hand cutting with a saw frame for piercing patterns, cutting and shaping all metals.

Polyurethane lacquer: a clear or coloured wood finish that dries by solvent evaporation, and produces a hard durable finish that can range from matt to a high gloss. This can be further polished if required.

Porosity: refers to missing particles of metal, a void, hole or space usually an outcome from casting of precious and non-precious metals.

Puk welding: a spot welding device with excellent ignition and welding characteristics for fixing or fastening work pieces prior to soldering or other additional processing. Suitable for spot welding on precious metals and precious metal alloys, on steel and steel alloys as well as titanium and some base metals such as aluminium.

Pumice: a volcanic rock used as an abrasive agent in preparation for polishing and finishing silver. This is also available in powdered form.

Pyroborate: the mineral salt sodium borate used for the flux borax in soldering. Commonly produced in solid cone form and used in conjunction with a ceramic borax dish. Grinding the borax cone with water in the dish produces a white creamy paste for applying onto surfaces in preparation for soldering.

Rapid prototyping: a group of techniques used to cut or build a scale model using three-dimensional computer aided design (CAD) data.

Rococo: also referred to 'Late Baroque', is an eighteenth-century artistic movement and style which affected several aspects of the arts.

Safety pickle: for cleaning oxides and fluxes from metals after annealing and soldering. A salt like powder that has to be mixed with water and heated for maximum cleaning effect.

Salver: a flat tray of silver or other metal on which drinks, letters, etc. are offered.

Sand casting: metal casting by using sand as a split mould material. Sand castings are produced in specialized foundries.

Glossary

Satin: a frosty like surface finish and appearance, applied on silver vessels as an alternative to a polished, directional or other metal finishes. A satin finish is often used in direct contrast to highly polished areas.

Schibuichi: an alloy that can be patinated into a range of subtle muted shades of green or blue through the use of rokusho treatments.

Shakudo: a copper and gold alloy that can be treated to form an indigo/black patina resembling lacquer. A dark colour is induced by applying and heating rokusho, a special patination formula.

Sharpening stone: blocks of natural or composite stone used to sharpen hand cutting tools, setting and engraving tools, scrapers, drills etc. Carborundum Oil and Arkansas stones are common to the silversmith.

Shibori: a hand raising technique where you hammer towards the physical body rather than the conventional method of away from yourself. It is the European equivalent to back raising, and gives greater vision of your hammering and striking of the metal.

Shot/bead blasting machine: sand blasting device that uses compressed air at high pressure with glass or ceramic shot/beads to texture and clean metal surfaces and areas.

Silver gilt: a term that relates to the gold colour on silver articles applied by using electroplating.

Spitstick: a sharp V-sectioned cutting tool mainly used for stone setting but an ideal hand tool for pushing up spitches for positioning and holding components in place for soldering.

Split chuck: chucks with five or more segments that enable shapes to be spun past the perpendicular. These chuck sections are withdrawn, split and removed on completion of a spinning, and can be used time and again for spinnings.

Spot welds: term used when laser welding individual spots to tack/hold components together to ensure everything is correctly aligned and in place before either using conventional soldering or continuing with laser welding.

Spruing: wire, usually round, connected to a master pattern in preparation for casting. These act as essential feeders for the molten metal to run into the master pattern when casting. Handmade metal master patterns require metal sprues attached before taking a rubber mould. Rapid prototypes need wax or plastic sprues connected to the pattern.

Stitches: small engraved stitches of metal used to hold and secure silver components in place during soldering.

Swarf: material removed by cutting on lathes, milling machines and grinding tools on metals, stone and other materials.

Sweetmeat basket: a small silver basket used to contain sweetmeats, a name given to food served in the final, sweet course of a meal.

Tailstock: a device used as part of an engineering or spinning lathe that applies horizontal support, centralizes work for turning, and is adaptable for drilling.

Tallow: a rendered form of beef or mutton fat used as a lubricant in solid form, when spinning for example.

Texturing: hammered, cut (hand or mechanical), rolled or etched are the main methods and techniques used for creating a texture on metal surfaces. Used as a decorative aspect on a vessel which can also receive enamel, different electro plated colours and surface finishes.

TIG welding: Tungsten Inert Gas welding is an arc welding process that uses a non-consumable tungsten electrode to produce the weld.

Troy ounce (oz): a pre-metric unit of weight used in the precious metals industry. 1 troy ounce is equivalent to 31.1035 grams.

Vacuum casting: method of casting where molten metal is drawn down into a plaster flask or mould by a vacuum of air. An alternative and popular method of casting in silver, gold, platinum and palladium.

Veneer: a thin surface layer as a decorative covering of wood, natural stone or synthetic material. It gives the impression of a whole piece of material in a cost effective way.

Vitreous enamelling: in simple terms, it is a thin layer of fused glass at high temperature on the surface of a metal, usually copper, silver or gold.

Water of Ayr stone: a natural grey stone sourced in Ayr, Scotland, and used for refining metal surfaces from filing and sanding in preparation for polishing. Use water when stoning on metal surfaces.

INDEX

annealing 54
anticlastic raising 176–177, 181–182
anvil 68
Appleby, Malcolm 126
Archambo, Peter 12–13
Aston Martin 167–168

Barnes, Phil 130–131
blocking 55–56
bouging 64
brass 39
Brogden, Alex 178–179
bronze 39
Bulgari, Nicola 2, 41
Burr, Clive 165–166

Carey, Dr Ann-Marie 146–153
carving 126
caulking 57–58, 63
chasing and repoussé 131–134
Chempix Ltd 135
chocolate pot 11–12
computer-aided machining (CAM) 137
computer-aided design (CAD) 137
Computer numerical control (CNC) milling and press forming 156–162
Cooksongold 37
copper 39
Cork, Angela 196–197

Daniels, Gemma 38
de Lamerie, Paul 13–16

Edge, Jenny 170, 176–177
Elkington & Co. 23–25
Elliot, Reg 110–119
enamelling 128–131
 basse-taille 128, 202
 champlevé 128, 130, 202
 cloisonné 129, 202
engraving 121–126
 computer engraving 127
equipment and machinery 44–45
etching 134–135
ewer 15–16

firestain 54–55
Fitzpatrick, Alan 111–119
fluxes 91
Forest, Marianne 29
forging 68–75
Formula One 164
Fox, Richard 28, 31, 43, 168–169, 164
fruit bowl 25–26

Gamester, Richard 40
Gilbert, Wally 172–173
gilding metal 39
Gill, Karina 134
glass 41
Good, Michael 181–182
Grey, Kevin 153–156, 194–195

Hallmarking and Assay 27–35
 Assay office mark 31
 hallmarking in the UK 30
 traditional marking 28
 sponsor's mark 30
 The convention marks 33
 The date letter mark 32
 The fineness mark 31
 The London Assay Office 33–35
 The UK assay offices 31
Hanid, Miriam 28, 31, 134, 189–191
Haselup, Gavin 109
health and safety 47–51
 chemicals 50
 COSHH assessments 49
 risk assessment 49
 safety signs 47–48, 51
H.G. Murphy 25–26
Hinton, Kathryn 156–158

Iijima, Yumiko 126

Jarvis, Richard 125
Joselyn, Rebecca 191–192
Johnson Matthey 149–150

Kelly, Rod 133, 179–181
Knight, Chris 174–175

laser welding 146–156, 203
laser cutting 140
laser marking 29
Lawrence, Christopher 79
Lee 'William' Sang-Hyeob 186, 188–189
Lord, Esther 192–194

INDEX

Macdonald, Grant 137–140, 167–168
Marsden, Samantha 124–125
master pattern making 109
Matthews, Sian 134–135
McCallum, Alistair 184–185
MDF 40, 204
Meeten, Wayne Victor 66–67, 133, 182–184
model-making 104–108
 fabrication in sheet 108
 hand fabrication methods 104
 stamping 106
mokume-gane 184–185, 204
Monteith Bowl 9–11

Need, John 92–103
Neville, James 121–124

O' Leary, Gavin 132
O'Connor, Heather 27, 29
Ottaway, Simon 158–162

Padgham & Putland 2, 40, 41, 42, 52, 67, 103–108, 162
Payne, Brett 36, 74–75, 171–172
Pearce, Edmund 9–11
peening 82–83
photo chemical etching 135, 204
pickling 55

plannishing 64–65
Plummer, Michael 18–19
Plummer, William 16–18
polishing 110–119
Pugh, Martyn 42, 146–153
pumice 68, 204

raising 53–67
raising with crimping/creasing 79–82
Ransom, Clare 38
rapid prototyping(rp) 107, 137–139, 204
Ravenscroft, George 9
R.H. Wilkins 127
Rich, Fred 79, 129–130
Rosewater Dish 23–25
Row, Jack 136, 140–146
Rundell Bridge and Rundell 20, 22
Russell, Toby 110

Sassoon, Adrian 174–176
Schlick, Benjamin 23–25
SCISS 163
scoring and folding by hand 83–88
Scott and Smith 8, 19–20
seaming 88–90
Short, Jane 120, 128–129
sideboard dish 13–15
silver 37–38

britannia 38
sterling 37
fine 38
sinking 76–79
soldering and silver solders 90–92
spinning 92–103
 basic 92–98
 split chuck spinning 98–102
stainless steel 39
steel and cast iron 41–42
stone 42
stone veneer 43
Storr, Paul 20–23
Suzuki, Hiroshi 175–176
sweetmeat basket 16–18, 205

teapot 18–19
tig welding 146–156, 205

Ward, Joseph 11–12
water fountain 12–13
water jet cutting 163
water of Ayr stone 68, 205
Watts, Zoe 195–196, 134
Weston Beamor 140–146
wine coolers 19–21
wood 40
wood veneer 41